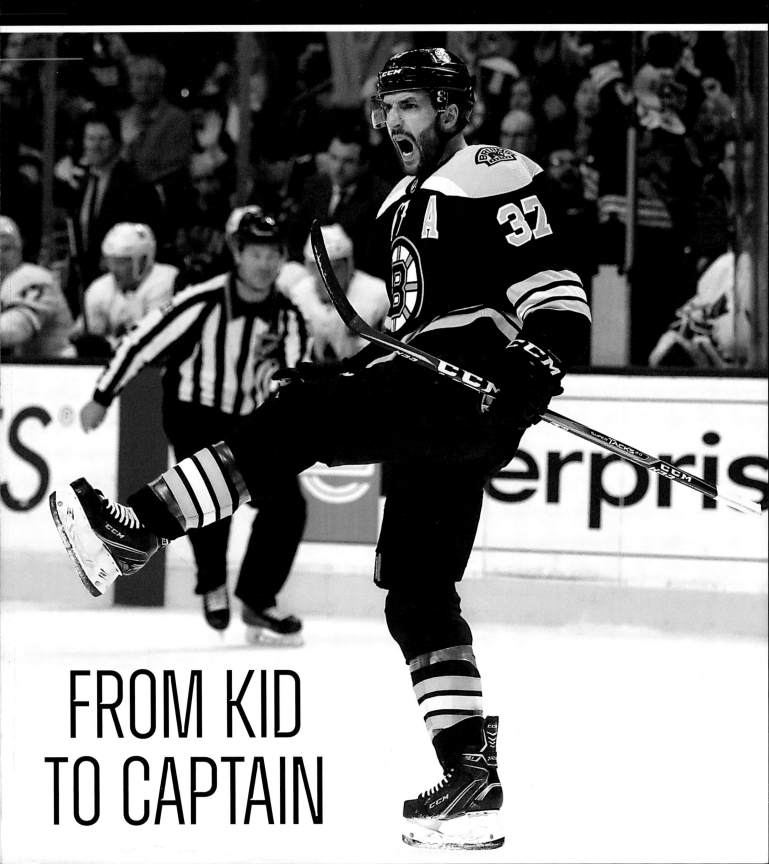

The Boston Globe
PATRICE BERGERON

FROM KID TO CAPTAIN

This book is available in quantity at special discounts for your group or organization.
For further information, contact:

Triumph Books LLC
814 North Franklin Street
Chicago, Illinois 60610
Phone: (312) 337-0747
www.triumphbooks.com

Printed in U.S.A.
ISBN: 978-1-63727-603-7

Book Editor
Matt Pepin

Book Contributors
Colby Cotter, Kevin Paul Dupont, Trevor Hass, Jackie MacMullan, Andrew Mahoney, Jeremiah Manion, Nancy Marrapese-Burrell, Kevin Martin, Barbara Matson, Jim McBride, Katie McInerney, Ira Napoliello, Matt Pepin, Matt Porter, Fluto Shinzawa, Tara Sullivan, Cam Tucker, Michael Vega

Boston Globe Photographs
Aram Boghosian, 59; Barry Chin, Back Cover, 2-3, 31, 32, 80, 95, 106, 110; Jim Davis, 5, 9, 20, 26, 35, 63, 64, 67, 83, 89, 101, 120; Stan Grossfeld, 85, 91, 119, 124; Justine Hunt, 86; David Kamerman, 41; Matthew J. Lee, 1, 11, 96; Mary Beth Meehan, 23, 25; Michele McDonald, 29; Evan Richman, 46, 49; Jessica Rinaldi, 99; Essdras M Suarez, 45; John Tlumacki, Front Cover, 50, 61, 69, 109, 113, 115, 116, 127, 128

Additional Photographs
AP Images, 14, 17, 19, 38, 42, 53, 54, 57, 72, 75, 76, 79, 93, 102, 104-105; CP Images, 37

Content packaged by Mojo Media, Inc.
Joe Funk: Editor
Jason Hinman: Creative Director

CONTENTS

INTRODUCTION

By Matt Pepin, Globe Sports Editor

The clues were everywhere.

Sprinkled throughout the pages of the Boston Globe in 2003, first in the summer and then with increasing frequency throughout the autumn, were telltale signs that Patrice Bergeron was more than just another Boston Bruins prospect.

On the day of the NHL Draft in June of 2003, then-Bruins general manager Mike O'Connell made a lofty comparison between Bergeron, whom he'd chosen in the second round with the 45th overall pick, and an elite playmaker whose career would lead to the Hockey Hall of Fame.

"He has a change of speed, looks one way and goes another, sort of like [Adam] Oates, that type of player," O'Connell said. "That's what he looks like right now."

Once training camp opened in September, effusive praise and glowing observations were a regular part of the Globe's coverage of the Bruins.

On Sept. 17, Marty Lapointe, the NHL veteran who'd taken Bergeron under his wing both on the job and at his own home, was quoted as saying, "He didn't come here just for an appearance. He's trying to prove himself and he's impressed a lot of scouts."

He also said Bergeron had "all the talent and all the tools."

Then this on Sept. 19, from Globe reporter Nancy Marrapese-Burrell: "Bergeron has been the biggest revelation in camp. It was believed he was going to head back to his junior team in Acadie-Bathurst but so far, he's making a case at the NHL level."

A day later, Marrapese-Burrell covered an exhibition game in which Bergeron scored the winning goal in overtime.

"No one turned heads more than Patrice Bergeron, who was the Bruins' second pick in the June entry draft," wrote Marrapese-Burrell, who quoted Bruins center Brian Rolston in the same article.

"He's a crafty guy and he can make plays," said Rolston. "He's been so good in camp."

As camp progressed, it became evident Bergeron had a very real chance to make the team.

In a Sept. 24 story about which players might fill the center positions on coach Mike Sullivan's third and fourth lines, Marrapese-Burrell again hinted Bergeron might be ready for the NHL.

"The most noticeable newcomer — and perhaps the frontrunner to this point — has been 18-year-old Patrice Bergeron," she wrote. "But whether he's ready to make the jump to the NHL from juniors so soon remains to be seen."

He was ready.

On Oct. 7, under the headline "Rookie bonus: Contract," the Globe reported that Bergeron had signed a three-year deal and would make his debut in the NHL just a few months after being drafted.

"There's no reason he shouldn't be on this team," captain Joe Thornton said.

That same day, Sullivan somewhat foreshadowed Bergeron's record six Selke Trophies as the NHL's best defensive forward, including one after his final season in 2023.

"Right now, his performance has shown he's capable of playing here. He's a guy who can play at both ends of the rink," Sullivan said ahead of the 2003 season opener.

In the years that followed, Bergeron's journey was well-documented by the Boston Globe. By 2006, the headlines and stories had shifted from describing Bergeron as a young rising star to a clear-cut leader of the team who was labeled in one headline as the "go-to guy for the Bruins."

He became one of the faces of the franchise, admired for his deft two-way play, his success at the faceoff dot, and his noble bearing. He spoke up when he needed to, and he let his play do the talking when that was the more effective way to send a message. He was embraced by fans in a city that adopted him.

He experienced the lowest of lows when he suffered a severe concussion and broken nose that cost him most of the 2007-08 season. There were more lows in 2013 and 2019, when the Bruins lost in the Stanley Cup Finals.

But he also reached the pinnacle of his profession when, as part of a loaded team that evoked memories of the Big Bad Bruins of the 1970s, Bergeron helped the Bruins win the Stanley Cup in 2011, ending a 39-year championship drought for one of the NHL's Original Six franchises.

With his name already etched onto the Cup, a "C" was added to Bergeron's sweater in 2021, which was a bit of a formality since he was already established as one of the unquestioned leaders of the team.

It appeared Bergeron was on the path to a second championship in his final campaign, when he led the Bruins through a record-setting regular season. The team set NHL records for both wins (65) and points (135) but was derailed in the first round of the playoffs.

After taking a while to make a decision about his future, Bergeron announced in the summer of 2023 that he would retire. A little more than 20 years after his selection in the draft was the second item in a story tucked away among many others the Globe sports department covered that day, it was easy to find the news of his retirement.

"Bergeron skates away in a class of his own," read the headline.

It was splashed across the top of the front page of the newspaper. ■

Second-round pick Patrice Bergeron was an impact player even as a rookie.

THE EXCITEMENT BEGINS

Bruins Grab Center Patrice Bergeron in the Second Round of 2003 Draft

By Nancy Marrapese-Burrell | June 22, 2003

The Bruins took center Patrice Bergeron with the 45th selection (second round) and nabbed left wing Masi Marjamaki with the 66th (second round) of the 2003 NHL Draft. Bergeron, who hails from Quebec City, turns 18 July 24. He said he hopes to emulate Philadelphia forward Simon Gagne.

"It was really exciting for me, it was an exciting day," said Bergeron, who had 23 goals and 50 assists in 70 games with Acadie-Bathurst of the Quebec Major Junior League. "It's maybe the first time in my life I can sit and wait and it doesn't matter for me."

Bergeron said he thought his playmaking and work ethic were the reasons he was drafted, and he wants to improve his speed.

"He has a change of speed, looks one way and goes another, sort of like [Adam] Oates, that type of player," said Bruins general manager Mike O'Connell. "That's what he looks like right now." ∎

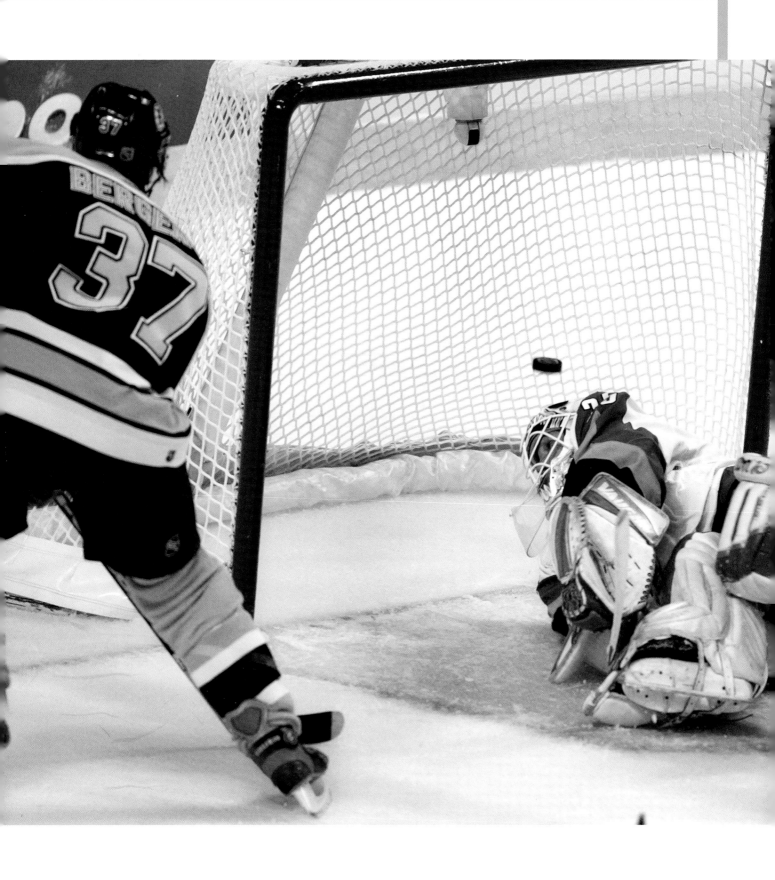

In a rare moment out of his famous number 37 jersey, Patrice Bergeron pulls away from Kevin Dallman in the annual Black-and-White intrasquad scrimmage

ALL ICING FOR BERGERON

Junior-Bound Pick Showing His Stuff

By Nancy Marrapese-Burrell | September 17, 2003

Patrice Bergeron knew his time with the Bruins in training camp would be limited, so his goal was to make a strong impression before being sent back to his junior team.

The 18-year-old center, who was taken with the 45th pick in the June draft, has opened some eyes. During one scrimmage, coach Mike Sullivan had Bergeron centering left wing Sergei Samsonov and right wing Glen Murray.

"It was pretty impressive," said Bergeron, who participated in the Bruins' annual Black-and-White intrasquad scrimmage at the Icenter last night. "I watched them last year on TV and it was amazing, and now to be with them, I'm a little bit nervous but I just have to not think about that."

"It's a good experience for me. I didn't know what to expect when I came here. I've learned every day from the older guys. I'm just 18 and I didn't know what to expect. I came in to get my feet wet and do what I can do and go as far as I can go."

Bergeron had a goal and an assist in a 4-3 losing effort last night, as the Black team won in a shootout over the White.

Bergeron, who hails from Quebec and will play for Acadie-Bathurst in the Quebec League this season, has been mentored by veteran right wing Marty Lapointe. Lapointe went out of his way to welcome the two French-speaking youngsters in camp — Bergeron and Benoit Mondou — and help them feel more comfortable. Bergeron

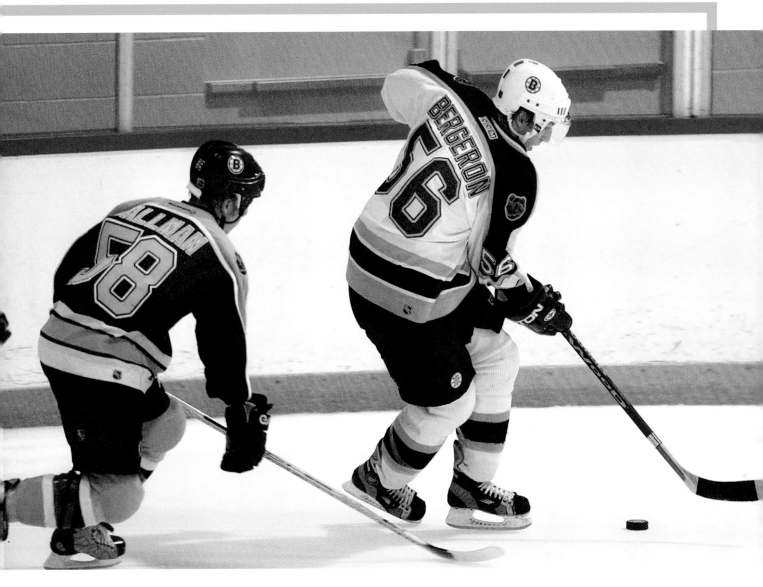

said it has been a monumental help.

"He's really intense and I learned that from him," said Bergeron. "Right now he's a model because I speak the same language and it's easy for me to go and talk with him.

"If I have a problem, he's there and he comes to see me. He told me to keep doing my things and don't be too nervous because it's the same game.

"I'm taking everything I've learned from the older guys back to my junior team and I'll try to do the same thing, like being disciplined and always being at your best in practice."

Lapointe was impressed with Bergeron's level of maturity.

"He made some sacrifices this summer to work hard and be in shape," said Lapointe. "He didn't come here just for an appearance. He's trying to prove himself and he's impressed a lot of scouts.

"I told him, when I was 18, I was a first-rounder and I wanted to make the team. He's got the same mentality, he wants to make the team but he's realistic. He doesn't want to make the big jump too fast.

"He's got all the talent and all the tools."

Now he just needs experience and seasoning.

"I think I made a good impression, but you have to get better on the ice," said Bergeron. "I saw where I have to improve." ■

ROOKIE BONUS

Bruins Keep Patrice Bergeron and Give Him 3-Year Deal

By Nancy Marrapese-Burrell | October 7, 2003

When Patrice Bergeron came to training camp, he was sure it was just to get his 18-year-old feet wet. He figured he'd spend a few weeks learning what the day-to-day rigors are like in the National Hockey League, play in a few exhibition games, and then would head back to play for his Acadie-Bathurst junior team in the Quebec League.

Instead, he earned a roster spot with Boston and signed a three-year contract with the club yesterday. He will be the first 18-year-old to play for Boston since Joe Thornton did as a rookie in 1997-98.

"I'm really happy about it," said Bergeron. "[The team] started to speak to my agent [Kent Hughes] two or three days ago. So I knew maybe I was going to sign, but before that I didn't know anything. I was taking it day by day and didn't know what would happen, but right now I'm pretty happy."

When the Bruins traded for center Travis Green Friday, Bergeron thought that meant he'd be sent back to get more seasoning. However, his consistency and potential led the Bruins to keep him.

"When I saw him arrive, I didn't know what to expect after that," said Bergeron. "But now I'm happy. I am just going to take it day by day."

The deadline for signing junior players is today, but Bergeron said he hadn't really concerned

himself with that very much, saying he trusted the team to make the right decision about his future.

One veteran who said he's thrilled the youngster is sticking around is right wing Marty Lapointe, who has served as a mentor to his fellow French-Canadian.

"That's awesome," said Lapointe. "I gave him a big hug and said, 'Welcome to the NHL.' He's a good little player. He's such a good guy, too. He's only 18 and he just told me it's a dream come true. I told him just to take everything he can [out of it] and enjoy it and have fun. Now he can concentrate on just playing and having fun and get some NHL experience."

Lapointe said he encouraged Bergeron, the No. 45 overall pick in the 2003 draft, not to get too caught up in the negotiation process and to concentrate as much as he could on hockey.

"When you start talking about contracts, it gets to you," said Lapointe, a 10th overall pick by Detroit in 1991. "Even though you don't want it to, I'm sure he was thinking about it. It's tough to stay away from it. You see all that glory, that money coming to you, and you can get sidetracked very easily. But he's terrific and not too many 18-year-olds are like that."

Thornton, who came in amid a great deal of hype because he was the No. 1 overall pick in the 1997 draft, said he thinks Bergeron has earned a spot.

"He's played well, he really has," said the captain. "He has a good head on his shoulders. He just has to be patient, work hard, and just have fun with it all. There's no reason he shouldn't be on this team. He's worked hard each and every day and I'm really impressed with how he's been playing."

And if he's eased in as Thornton was by former coach Pat Burns, Thornton said he didn't believe it would retard Bergeron's development.

"You look at my first two years, I was getting three or four minutes a game," said Thornton. "I wasn't lighting anything on fire scoring a lot of goals. But you just learn so much, just through the behavior in the locker room, the tempo out there, and just the experience."

According to coach Mike Sullivan, Bergeron has fit in well and has been impressive in his nine exhibition games with the team, during which he scored two goals and had an assist.

"I think it's a great experience for him to be here and practice with NHL players," said Sullivan. "Right now, his performance has shown he's capable of playing here. He's a guy who can play at both ends of the rink.

"He has an awareness and I think he has a maturity level beyond his years. For every game he plays, he'll get better."

General manager Mike O'Connell said what swung the decision was that Bergeron's play never slipped.

"He kind of reminds me of [Kyle] McLaren," said O'Connell, referring to the defenseman who made the team at 18. "They're different players, of course, but Bergeron is the same case [in terms of their consistency throughout training camp]. Usually there's a dropoff, but there hasn't been. He's fit in. I met with him after we signed him and told him it's a whole other level now."

And Bergeron will find that out soon enough. ∎

A young Patrice Bergeron fights for the puck sans helmet during his rookie season against the Flyers.

BACK TO BUSINESS

Patrice Bergeron and Young Bruins Show Signs of a Promising New Era

By Kevin Paul Dupont | October 9, 2003

Maybe it's the bountiful time in which we live, what with the Patriots being the not-so-distant Super Bowl champs and the Red Sox in the thick of their Curse-bustin' crusade, but it's hard not to detect a subtle and encouraging wind change on Causeway Street. And not simply because of last night's entertaining and, at times, dramatic 3-3 tie with the Devils.

Hey, something had to happen, and fast, after another painful and ugly Bruins playoff implosion last April. A decade-plus of mediocre, bad, worse, and outright revolting hockey had — and might still have — many of Boston's puck-lovin' faithful fed up with the hometown team.

It's not all going to get better overnight, and the underlying reason for that is how badly the product atrophied here since the early '90s. Who knows better than a Bruins fan that it's a long and very lonely way back?

Nonetheless, there are some real reasons to be encouraged.

First and foremost, it finally looks like the scouting department has found some kids who will be players. The Devils are about the NHL's best example of building from the bottom up. General manager Lou Lamoriello has developed a time-tested system of drafting and developing players, perfecting the art of roster back-and-fill with teenagers and young twenty-somethings. To

Rookie Patrice Bergeron slips the puck past New York Rangers goalie Mike Dunham.

get up to pace with the Devils, the Bruins would have to string together at least 3-5 more good drafts, but the opening-night roster showed initial evidence that the scouting staff is finally getting it.

Exhibit A: Patrice Bergeron.

No one should put the Calder Trophy Committee on red alert just yet, but the 18-year-old Bergeron has some old-timers (see byline above) thinking back over 20 years to the all-too-brief run of Normand Leveille. Bergeron is a pivot, not a wing, and he's a smoother, more refined specimen than the bullet-fast, hard-shooting, raw-cut Leveille. But there are the obvious comparisons: young, French-Canadian, talented, forward, and most of all, tantalizing. How about this for coaching confidence: Mike Sullivan rolled Bergeron over the boards in the final minute of regulation, the score at 3-3. Few freshmen instill that kind of trust, especially in NHL career game No. 1.

Leveille's career came to a cruel and sudden ending, a cerebral hemorrhage during an October game 1982 in Vancouver, leaving him partially paralyzed to this day. If the deck of cards that is fate holds a wild card, then Bruins fans can hope that Bergeron, born in Ancienne-Lorette, Quebec, is the deuce they've been waiting to be played in Leveille's memory for years.

Exhibit B: Milan Jurcina.

The Slovak defenseman did not suit up last night, but he'll get his chance soon. Of everything there is to like about Jurcina, including his 6-foot-4-inch, 200-pound frame and long reach, there is also that No. 241 next to his name in the media guide. In the 2001 draft, there were 240 other players around the world deemed more NHL-worthy than the big bruiser from Liptovsky Mikulas, Slovakia.

If the folks who head up the teenybopper scouting search, including assistant GM Jeff Gorton and top scout Scott Bradley, can find an NHLer at No. 241 (remember, Hal Gill was No. 207 in 1993), then what we have here is a real momentum shift, a market correction. The best picks come in the first round (witness: Joe Thornton and Sergei Samsonov). The best finds come later, when all the hype has been shaken out of the draft. Based on his training camp, Jurcina looks like a find.

Exhibit C: Andrew Raycroft.

If he's ready, and it may take a couple of months to figure that out, Raycroft's impact on the Bruins could be profound. He's only 23, and although some goaltenders make it very early (witness: Martin Brodeur and Patrick Roy, just to name a couple), 23 still qualifies as an outright newbie. If by the end of this season the Bruins can say they've finally drafted and developed a legitimate No. 1 goalie, then that could equal the impact of — chin straps buckled, please — the trade that brought Cam Neely here.

We know 50-goal scorers fall out of the sky about every 20-25 years. But ask yourself, how often do 40-win goalies show up here in the Hub of Hockey, or anywhere? One day it's bound to happen, and the lithe, technically sound Raycroft presents the chance. That alone is unique. Raycroft backed up Felix Potvin in the opener and Potvin (32 saves) was encouragingly sharp much of the night.

Look, I'm not sold on Martin Samuelsson and/or Ivan Huml, just as I'm not totally gonzo-for-goals over the likes of Bergeron, Jurcina, or Raycroft. But at least there is some bona fide upside to these guys, and a degree of validation that Gorton and Bradley can tell a prospect from a reject. Add to that the proven sharp eye of Sean Coady, the chief pro scout who identified the likes of Ian Moran and Dan McGillis to be brought here last March, and it leads to the belief that Mike O'Connell and Co. may finally be bringing the product out of what has been a very long, cold storage on Causeway. Jeff Jillson popping in a pair of goals also speaks well of finding guys who fit.

Please, no more Paul Coffeys and Andrei

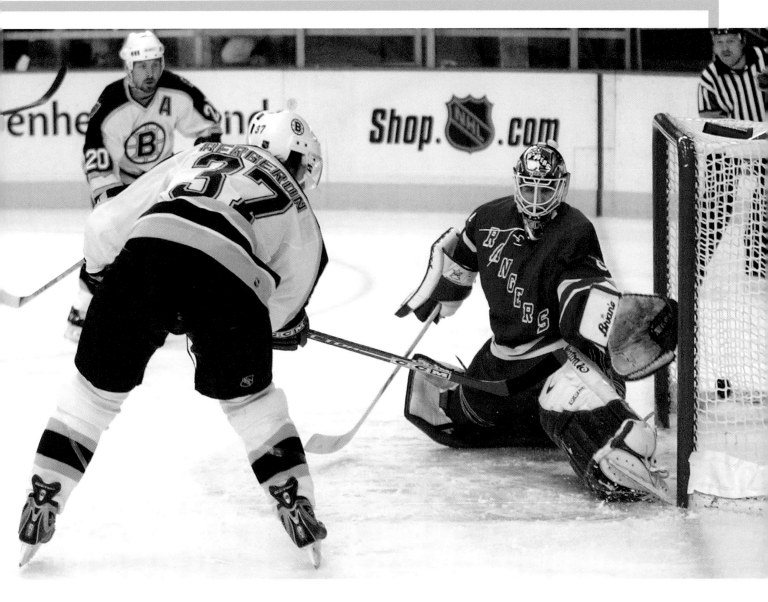

Kovalenkos. Not another Steve Shields. Not another Kevin Stevens. And please, no more Krzysztof Oliwas or Andrei Nazarovs, OK? The first two years of Marty Lapointe have had their moments, but on balance, he has labored in the D-plus/C-plus range while pulling down A-plus money. It's one thing to augment a lineup with low-budget pickups such as Sandy McCarthy and the moderately priced Travis Green. If they don't work out, it's not devastating. But to pour $5 million-plus per year into a D-plus/C-plus performer brings down the whole product.

There are still 81 games remaining on the 2003-04 regular-season schedule, and no one here is pretending that the Bruins are going to stay abreast of New Jersey, Ottawa, Detroit, and Colorado, the NHL's creme de la creme. They are simply not ready to run with the big boys. Nor will the promise of a handful of kids change the fortunes of a bedraggled franchise in one fell swoop. There will be growing pains, like the 12-1 shot advantage the Devils held late in the first period last night, and growing pains come with youth, walking arm in arm with promise.

Will there be a Stanley Cup parade here in the spring? Not in your wildest Johnny "Pie" McKenzie dream. But the good news is, at least the nightmare appears to be ending. ∎

An early highlight of Patrice Bergeron's rookie campaign was this game-winning goal against the Kings.

≫ BRUINS 4, KINGS 3

October 18, 2003 • Los Angeles, California

SNAPPING OUT OF IT

Rookie Bergeron and Bruins Overcome Lousy Start, Stun Kings

By Nancy Marrapese-Burrell

t's hard enough to play a road game under the best of circumstances but when you stake the home club to three goals in the opening period, your chances of a comeback are remote.

It can happen, however, as the Bruins proved against the Kings. They held Los Angeles without a shot in the third period and scored a pair of goals 44 seconds apart late in regulation to earn an improbable 4-3 victory over the Kings at the Staples Center.

Rookie Patrice Bergeron pulled the Bruins even during a power play at 17:28 with his first NHL goal. Mike Knuble, reunited with Joe Thornton and Glen Murray on the top line, won it with a goal at 18:12.

Coach Mike Sullivan ripped his team during the first intermission, telling players their performance was unacceptable.

"I said a lot," said Sullivan. "I told the guys, 'What is it going to take for us to figure out how you win in this league?' In my mind, it's no secret. The teams that are successful are teams that don't beat themselves. This is something we talk about every day. Taking undisciplined penalties is one of the easiest ways to beat yourself. I challenged them and told them, 'This is a gut check. What's it going to take?' "

Knuble said the coach's message was the kick in the pants they needed.

"It's pretty much black and white," said Knu-

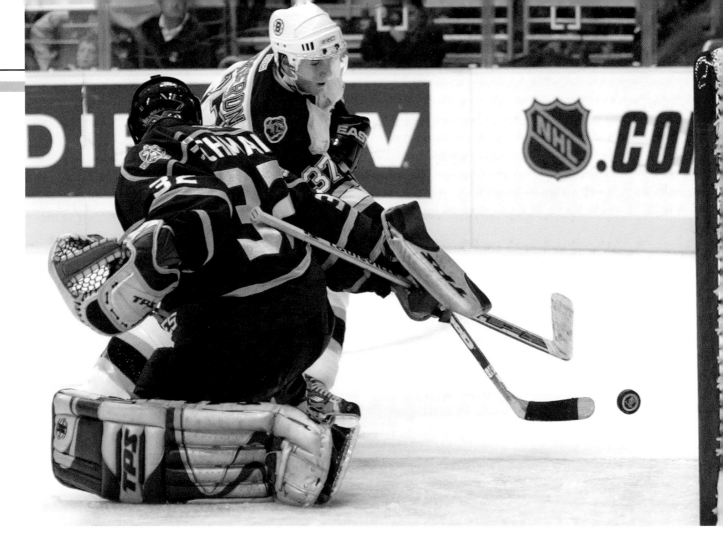

ble. "When we stop taking penalties, we can play with anybody. I think we learned something. I don't know how dumb we are. It's almost like we are stupid, we have to realize we can't take penalties like that."

The Bruins displayed an appalling lack of discipline in an opening period dominated by the Kings. Los Angeles scored three power-play goals — two by Luc Robitaille and one by Lubomir Visnovsky — to take a 3-0 lead in the first 20 minutes. Two of the goals were scored during a two-man advantage. Boston gave the Kings seven power-play opportunities in the first period and Los Angeles generated 12 shots during the 11 minutes 26 seconds that the Bruins were shorthanded.

The Bruins continued racking up penalties in the second period. Marty Lapointe was called for boarding defenseman Tim Gleason, giving the Kings their eighth power play of the game after the two squared off. Another fight erupted between Nick Boynton and Ian Laperriere. At 6:19, center Sean Avery sparred with Thornton, prompting defenseman Jeff Jillson to the Bruins captain. Jillson received a game misconduct

and Thornton was assessed a double minor for cross-checking and roughing, while Avery received just two minutes for roughing.

With the Kings on yet another power play, Robitaille tried for the hat trick, ripping a shot from the right circle. But Felix Potvin, who had been on the far side of the crease, reacted by lunging to his left and snaring Robitaille's bid.

At 13:19, the Bruins got on the board as a result of hard work by the fourth line. Forward Sandy Mc-Carthy took a pass from 18-year-old Bergeron and beat goalie Roman Cechmanek to the glove side with a forehand shot from the high slot. The goal inspired Boston and for the rest of the period, as the visitors kept pressure on the Kings. Boston outshot the Kings, 12-3, in the second period.

The Bruins pulled within 3-2 at 4:51 of the third. Brian Rolston, who had both of Boston's goals in Dallas, potted his third of the year one second after the club's power play expired when he drilled a slap shot from the point past Cechmanek. ∎

Even though Patrice Bergeron's sophomore season was put on hold due to the 2004-05 lockout, his 39 points during his rookie season would be a sign of things to come.

GROWTH SPURT

Even with NHL at a Standstill, Young Bergeron is Going Places

By Nancy Marrapese-Burrell | January 9, 2005

When Providence Bruins public relations director Adam Alper picked up star center Patrice Bergeron at Logan Airport Wednesday night as Bergeron returned from the World Junior Championship in Grand Forks, N.D., he noticed something peculiar. In the middle of Bergeron's stack of Reebok sticks was a lone Sherwood.

The stick was a gift from linemate Sidney Crosby, who is expected to be the No. 1 selection in the next National Hockey League draft. The pair, who became close friends while rooming together during the competition, led Team Canada to a gold medal with a dominating attack.

The 19-year-old Bergeron, who captured Most Valuable Player honors in the tourney, said his stick collection now numbers exactly one — and the fact that he worked up the nerve to ask a fellow player for one symbolizes the remarkable strides he has made in his development and maturity, on and off the ice.

In September 2003, the Quebec native came to Boston's training camp for a taste of the big time, three months after he was taken with the club's second pick (No. 45 overall) in the draft. He was expected to stay for a couple of weeks, play in a few exhibition games, and then head back to his junior team. Instead, his performanc-

Patrice Bergeron and his teammates spent the lockout season playing for Boston's minor league affiliate, the Providence Bruins of the American Hockey League.

es were so impressive that he earned a roster spot and was in the running with teammate Andrew Raycroft for NHL Rookie of the Year honors until a shoulder injury in late February sidelined him for nearly a month.

After the Bruins were eliminated in the first round of the Stanley Cup playoffs by Montreal last spring, Bergeron was freed up to represent Canada at the World Championship, where his team won a gold medal as well. This year, with the NHL players locked out, Bergeron signed an American Hockey League contract with Providence that included a clause to allow him to play in the World Juniors.

He was reunited with players his own age for the first time since junior hockey.

"I learned a lot of things," said Bergeron. "Maybe I was missing playing with some guys my age. I liked it a lot. But I wouldn't change last year for anything. I learned to be a leader a little bit. I was always playing older guys and I tried to be a leader, but I was always the youngest. I was quiet. Now, I'm starting to talk a little bit more and I had some more experience than some other guys, so it was kind of different."

Last season, the French-speaking Bergeron was reserved, in part because he wasn't yet comfortable with English. He was accommodating to the media, but he's improved by leaps and bounds since then.

"It took me some time," he said. "Last year, I wasn't confident at all. I didn't mind speaking, but I wouldn't be the one who was going to stand up and talk in front of, like, 30 people in English. Even in French I wouldn't do it. But I feel more comfortable with English now. I needed some time to learn it. It was just a matter of getting some confidence."

Bergeron's faith in his on-ice skills has never wavered. On the first day of Team Canada's World Juniors training camp, coach Brent Sutter put him with Crosby and winger Corey Perry, an Anaheim prospect.

"The chemistry [developed] pretty quick," said Bergeron, who had 13 points (five goals) in six games. "I'd heard about [Crosby], obviously. I was impressed. He's very humble. Even with all the media around him, he stays down-to-earth. He's got such good vision and he's such a great player. Perry

Patrice Bergeron's time with the "Baby B's" proved essential to his development, as he tallied 61 points in 68 games.

is really skilled. He's a sniper. He's pretty tall. We had three guys with good vision, so it was a pretty good combination."

As much as there is a pall around pro hockey because of the lockout, Bergeron has been able to mine opportunity out of disappointment.

"Obviously, I'd like to be in the NHL right now, but there are some things I can't control," he said. "I don't think I would've been able to be at the World Juniors if I'd been in the NHL this year. Obviously, it's not the best thing, but it gave me the [chance] to be there."

Where it ranks on an excitement scale in his young life, Bergeron couldn't say.

"It is up there, for sure," he said. "It's not higher than making the NHL last year, but it's a great feeling."

The Bruins front office was impressed not only by his performance but by his maturity level, which has risen through each stage of his burgeoning career.

"The fact he won MVP says a lot — on probably the most dominating performance maybe in the history of the tournament," said Bruins assistant general manager Jeff Gorton. "He was good in all facets of the game. He played against the other teams' best lines and yet he was the leading scorer and played with Crosby and Corey Perry, two pretty good players.

"He's a special player. The great thing about him is, as good a player as he is, he's a great kid. To consider what he's done and the fact he's only 19 and he came into our team [at 18] and not only did he make it but he was a significant piece of the puzzle and was able to play wing and center, kill penalties, and do everything at the NHL level at his age. Then, go on to the World Championships and win a gold medal and then go to the World Juniors and be MVP and win a gold medal.

"If we had said we expected all this, we'd probably be fibbing a little bit."

Becoming a leader

If the NHL lockout continues, Bergeron will be leading the Baby B's for the rest of the season,

playing on a line with Andy Hilbert and Keith Aucoin. Although play in the AHL is more scrambly than in the NHL, Bergeron said there are plenty of lessons to learn at that level.

"The guys are really intense from the first line to the fourth line," he said. "That's great, because I'm going to learn from that. Guys want to make the jump to the NHL, so they're intense every game. You can see they love playing hockey, so it's all good things I'm going to learn from them."

Last season, Bergeron lived with right wing Marty Lapointe and Lapointe's wife and three children; the veteran served as mentor and surrogate big brother. Bergeron may be more independent now, but he continues to reap the rewards of Lapointe's tutelage.

"He broke into the league at 18 and had Marty Lapointe helping him out and his family being so good to him that way," said Gorton. "Then all of a sudden you see him over there at the tournaments, he's with Crosby, mentoring Crosby as if Patrice had been around for 100 years. That's just the kind of kid he is. Every situation he's ever been thrown into, he's thrived and he's only going to get better."

As Bergeron's career progresses, he'll surely collect more sticks from friends he makes along the way, but his own are increasing in value, too. In fact, Crosby asked for one before they headed home.

"I don't know what he's going to do with it," said Bergeron.

"I'm sure Crosby has a pretty good idea of how good Patrice is going to be now," said Gorton. "It was probably a pretty good eye-opener on how good NHL players are for Crosby. To see a guy like Patrice, the way he performs and goes about his business, it has to be eye-opening."

Maybe now, Bergeron can add a second stick to his collection — from Lapointe.

"I was too shy last year to ask for sticks," he said. "I should've, but . . . I didn't even ask Marty. That tells you how shy I was."

He's come a long way. ∎

By the start of the 2006-07 season, Patrice Bergeron had become the go-to-guy for the Bruins.

STAR TURN

Patrice Bergeron Now Go-To Guy for Bruins

By Jackie MacMullan | October 6, 2006

The money is a measuring stick. Patrice Bergeron is only 21 years old, but nobody has to explain that to him. When the big dollars kick in, so do the enhanced expectations, and the heightened disappointment if certain requirements are not met.

Before the contract, he was a kid with exceptional skills and an unparalleled hockey IQ who represented hope for a franchise mired in mediocrity. Once he signed his five-year, $23.75 million contract with the Bruins in August, he was immediately upgraded to young star who must come through.

"You are right," said Bergeron, shortly before he left town for Boston's season opener in Florida against the Panthers. "I have to produce."

What will be enough to soothe the masses? Depends on whom you ask. Most Bruins fans merely want a consistent scorer who can guide Boston back into the postseason. But others will expect Eric Staal numbers. Staal, the second overall pick in the 2003 draft (the same draft in which Bergeron was selected 45th), scored 100 points for Carolina last season en route to the Hurricanes' march to the Stanley Cup.

Hurricanes fans have yet to match the fervor and passion of the Black and Gold. If you succeed, fans in this hockey hub will adore you like no other. But if you come up short, your life can be difficult. Bergeron witnessed that in his rookie season, when he lived with veteran Marty Lapointe.

Along with burgeoning stardom on the ice, Patrice Bergeron was quickly becoming a fan favorite early in his career.

Lapointe had inked a four-year, $20 million contract in 2001, but was plagued by injuries and did not fulfill the hopes of management or the fan base.

"My contract was definitely an issue," said Lapointe. "Bergy and I didn't talk about it, because he probably felt it wasn't his place to say much. But he is the kind of person who sat back and took in everything that was happening.

"We'd leave the rink together after most every game. The autograph seekers would be there, and I'd stop, and try. But there always seemed to be one guy who wanted to say, 'What makes you think you're worth $5 million?' From the outside looking in, it doesn't seem bad, but when you're in it, it can be tough."

Suite gesture

In the midst of the team's infuriating implosion last season, Bergeron, who potted 31 goals and 42 assists, was a glimmer of light. It was not surprising, therefore, that new general manager Peter Chiarelli established locking up Bergeron for the long haul as one of his first orders of business.

Bergeron's pals back home in Quebec cracked open some Molsons and then began grilling their friend about what he should do with his new fortune. Buy a new car? A new house? No. The apartment in Boston, with a room set aside for visits from his parents, was sufficient. So was his SUV, an Aviator, which runs just fine.

Forget the boat, the watch, the trip, the designer suit, and the Jacuzzi, too.

The only thing Patrice Bergeron finally settled on was a box.

It's a luxury box, actually. Within days of signing his contract, he purchased a suite where he could host underprivileged or ill children.

"I love kids," he explained. "I thought if I could bring sick kids or poor kids to a game maybe I could put a smile on their face, even if it's just for one day."

He will donate tickets to Children's Hospital Boston for the home opener and the Big Brothers

Patrice Bergeron and teammate Marco Sturm celebrate Bergeron's overtime goal to beat the Maple Leafs.

Big Sisters program for the game after that. From there, he will rotate among deserving charities.

"I didn't buy anything for myself," he said. "I'm trying to stay low-key. I don't want to change just for changing.

"I did want to do something for my parents. But every time I try, they say no. It's kind of crazy. They give and they give, but they won't take anything back."

The money is inconsequential to Bergeron's parents. They are comfortable, his mother, Sylvie, explained. They don't need a thing, except to ease their worries about their son being thrust into a pressure situation at such a young age.

"It's important for him to keep his head on his shoulders," Sylvie said. "I want him to stay the same."

Her boy has never been boisterous. Even as a child, he was uncommonly attentive to his surroundings. He listened more than he talked, and learned more because of it. No wonder his vision on the ice is one of his most valued assets.

"He hears everyone around him," Sylvie said. "He would come home and say, 'I learned this today about my teammates. I learned to be patient today.'

"His expectations for himself have always been so high. When he goes onto the ice, he always wants to be perfect. For a mother, it seems a little too high. I tell him not to put too much pressure on himself."

Poise of a veteran

Pressure is inevitable. Always has been. By the time Bergeron was 15, the scouts had him tagged as a future NHL talent. But then he was cut from the Triple A Jets, a competitive team just below the junior level.

The rejection was initially staggering.

"It was an awful day for him for about two or three hours," Sylvie said. "But then, he came out of his room and said, 'OK, that's the past now.' "

The next season, Bergeron made the Jets and dominated. From there, his career was firmly on the fast track. In 2003-04, he was the NHL's youngest player, posting 16 goals and 23 assists. Last season, Bergeron was touted as a key cog in the "new-look" Bruins, rated in preseason as Cup contenders. Instead, they were dismal underachievers, and the face of the franchise, Joe Thornton, paid the price.

"Bergy's been through a lot in three years here," noted Glen Murray. "He carried a bad team last year. We traded Joe, our best player, and they said, 'There you go, Patrice.' He stepped in and was unbelievable after Joe left.

"And he took it all in stride. He can handle the pressure. He doesn't worry about much of anything."

That wasn't always true. As an 18-year-old rookie who spoke limited English, Bergeron felt blessed to be embraced by Lapointe, who invited him to live with his family. Bergeron volunteered to baby-sit, grocery shop, even wash windows.

"Marty was so great to me," Bergeron said. "I could talk to him. He could tell if something was bothering me. We talked about pressure. He helped me with things off the ice. He opened a bank account for me."

Lapointe also included him in many social functions and marveled at his ability to maintain his composure.

"His maturity level was just so high for a kid that age," Lapointe said. "Sometimes we'd go out after the game. I'd have a couple of friends with me, and we'd be having a few beers.

"Patrice might have a bottle in front of him, but all he did was smell the cap. Half the time he didn't even finish it. I was impressed by that. I don't like to think about how I would have handled that at 18."

Bergeron noted how Lapointe handled his own disappointments with grace. He listened as his friend and teammate reminded him never to

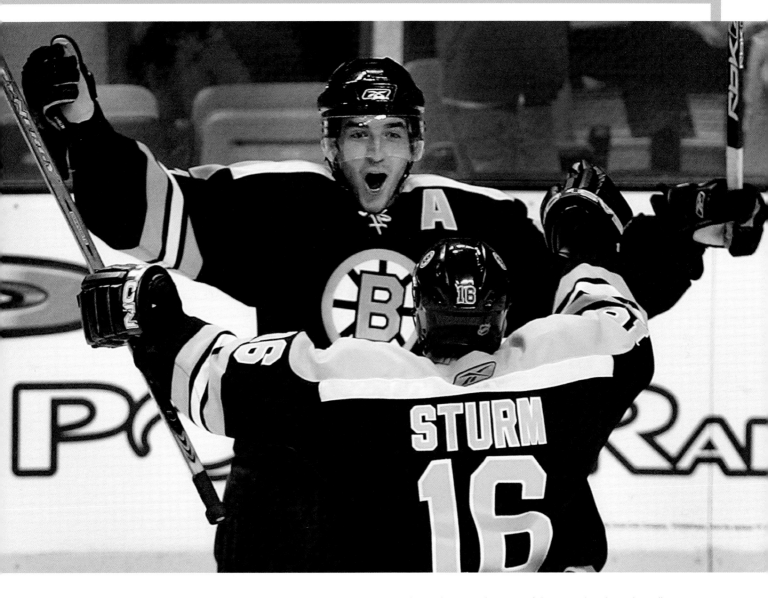

let money dictate his happiness, or his true worth.

Now Bergeron hopes to pay that favor forward by investing in Phil Kessel, the new rookie who will join him on a line with winger Brad Boyes.

"I'm trying to be there for Phil, like Marty was for me," Bergeron said. "We're very close in age, so I'm trying to be a friend more than a mentor."

The most prominent new face on the roster is Zdeno Chara, the imposing defenseman who was named team captain with Bergeron and Murray as alternate captains.

"What I noticed right away about Patrice was he was a very hard-working guy," Chara said. "He wants to have a good practice every day. I was very happy to see

our best player is also one of the most hard-working."

Bergeron watches his diet, exercise regimen, and extracurricular activities. Those are the notches on his measuring stick. The dollars are of no use in such matters. You can't buy goals, wins, or credibility.

"People will talk about the contract," Lapointe said. "But let me tell you something. By the second or third year of that deal, Patrice will be underpaid." ∎

Patrice Bergeron was all smiles as training camp got underway in 2007.

A PACT TO IMPROVE

Bergeron Vows His Offseason Conditioning Will Pay Off

By Kevin Paul Dupont | September 12, 2007

The snowy pile of Zamboni detritus offered scant competition for the late August sun, radiant and warm and penetrating. Amid the meltdown, two young boys, mischievously and genetically predisposed to such summer serendipity, seemed to appear out of nowhere to wage their snowbrawl royale, their guerre de neige, here outside Arena les 2 Glaces.

"Quebec is a special place; I love it here," mused one of La Belle Provence's hockey homeboys, Patrice Bergeron, he and a visitor from Boston sitting outside the practice rink within a short lob of the prepubescent warriors. "Boston is really unique also ... big, but small at the same time ... you can get around quickly."

Bergeron, 22, is about to begin his fourth NHL season, his stardom dropped upon the Hub with the suddenness and surprise of a midsummer Back Bay blizzard. All of 152 NHL games to his credit, he signed a five-year deal last summer that guarantees him an average $5 million plus through the spring of 2011. On the fast-forward road of NHL financial success, he hit the jackpot, and followed immediately with a 2006-07 season that, like the Bruins as a whole, was long on inconsistency and far short of its promise.

"Last year, a lot of things went wrong," said Bergeron, his production of 70 points only a 3-point drop from his sensational sophomore season. "I am aware of that, and I want things to change. Every time you learn, you improve. I think maybe I tried to do too much."

The standard was high for the 2007-08 Bruins, powered by veterans Zdeno Chara, Marc Savard, and a young Patrice Bergeron.

Indeed, much like defensive behemoth Zdeno Chara, Bergeron paid a price for his talent, his willingness, and his versatility. In the fractured and oft-befuddling game plan cobbled together by then-coach Dave Lewis, Bergeron was at times painfully overused, especially so considering that he was also hurt — an issue that he steadfastly refuses to discuss.

"Lower body, in a couple of places," said general manager Peter Chiarelli, emphatically stating that Bergeron was hurt more than the talented pivot let on, more than media and fans were aware. "I'd call them injuries that were in wear-and-tear areas, you know, consistent with overuse."

But best left undisclosed and undiscussed, according to Bergeron. All in all, it was a season not to remember, only in part because of injury.

"I just don't like to talk about it," he said. "Because it's not about that now, it's about being a better player."

Perhaps equally painful was the glaring minus-28 that was also part of his 2006-07 dossier. Of the 858 NHL forwards and defensemen who suited up last season, Bergeron and Montreal defenseman Sheldon Souray (now an Oiler) finished T-855 in plus-minus. Only Joffrey Lupul of Edmonton (minus-29) and R.J. Umberger of Philadelphia (minus-32) ranked lower on hockey's yin-yang scale.

"Not a stat I'm proud of, that's for sure," acknowledged Bergeron. "Especially when I say I take pride in my defense. I want to change that — and not just that, but everything. I want to get back where there is confidence in me, confidence [among] my teammates.

"I want to get back and play — that's it."

Summer work

The return officially begins tomorrow when all Bruins veterans must report to Causeway Street for physicals. Whatever ailed Bergeron last year,

he says it is now a nonissue. He is healed and ready, intent on stepping up his game, or at least getting it back on par with the standard he set with what now stands as his platform season of 2005-06.

He returned to his home in Quebec City soon after exit interviews last spring, and then took his mom, dad, and brother on a vacation to Mexico. Upon returning, he quickly began to resume workouts with his longtime personal trainer, Raymond Veillette, and power-skating coach, Julie Robitaille. Veillette and Robitaille have been with him since soon after he turned pro with the Bruins, in the months following the 2003 draft when he was chosen No. 45 overall.

The 2007-08 version of Bergeron is the same size, a compact 6 feet and 195 pounds. Upon close inspection, he appears slightly broader across the shoulders, a result of his summertime workouts. But most of all, said Bergeron, his emphasis was on building up his aerobic capacity, specifically his endurance, something he identified as a need last season, especially during the busier weeks of the 82-game schedule.

"Today I played for an hour and a half, and it felt good," said Bergeron following an intense scrimmage with a gathering of other Quebec-based NHLers, including Simon Gagne, Antoine Vermette, Francis Bouillon, and others.

"You want to change stuff. Every year I come back, I talk to [Veillette]. He asks what was good, what was wrong, and this year he changed some of the cardio stuff, worked on my legs, and I feel stronger.

"Some of the change is just because of age — I'm getting older — and I ended last year thinking that I had to be not necessarily stronger, but I had to increase my endurance. When we had a lot of games in a row, say four games in a week, or two games with a night off followed by another game, it was that fourth game that I didn't feel 100 percent."

The increased leg strength and improved aerobic integrity, along with better luck on the injury front, could go a long way in returning Bergeron to his "A" game.

Connecting with coach

"He's the first to admit that he didn't have the year he wanted," said Chiarelli. "And I had a number of people say to me last year that he didn't have his jump, that he didn't skate as well as he had previously. But I saw it in stretches.

"And you know, before I came here, I knew he was a very good player, but I'd say my view of him, seeing him play night after night, changed dramatically. He does a lot of those little unselfish things that don't get noticed.

"I knew he was strong. I knew he could put up points. But there were times when he took the puck, and he was so strong, so determined ... I've only seen that in a couple of players, and the other one is [Marian] Hossa."

It's likely that Bergeron will play a more defined role under new coach Claude Julien, whom he played for when he suited up for Team Canada in the 2006 World Championships in Riga, Latvia. (Julien was an assistant coach.) Julien wants to implement a strong forechecking system, which is perhaps Bergeron's strongest suit.

Under Lewis, the Bruins rarely deployed a forecheck, and if Julien has Bergeron spearheading that

Patrice Bergeron practices at a local arena in Quebec City prior to the 2007-08 campaign.

pressing attack, it could mean he would see slightly less time on the power play. Game situations, and especially the score, could dictate how his minutes are budgeted. Meanwhile, Bergeron liked what he saw and heard of Julien in their brief time in Riga.

"He's really good about telling you your role, what he expects of you - he wants you to be intense on the ice," said Bergeron, his own searing intensity and understated demeanor very similar to that of Bruins icon Ray Bourque. "When he speaks, he's very good at explaining what he wants out of everyone, what he wants for a system. Basically, he wants everyone to be hard on everything — hard on the puck, hard along the boards, hard on body checks. Intensity."

By the end of August, Bergeron was skating four days a week, and augmenting the scrimmages with off-ice workouts. He doesn't talk about 2007-08 as if it's redemption-in-waiting, but his disenchantment with last season is clear, as is his pledge to make things better.

"I have some objectives in my own mind," he said. "But I will keep them in my mind — I don't want to say what they are."

In the starting gate

Chara is expected to wear the captain's "C" again, with Bergeron and Glen Murray again projected to wear the alternate captain's "A." Better perhaps, the way Bergeron sees things, that everyone in Black-and-Gold should have a leader's "L" on their shoulders.

"We all know Z is the captain, but we all have something to bring," he said. "We all have leadership to bring to the game. Really, I don't think it matters who does what — it doesn't matter if you have an 'A' or a 'C' or whatever.

"I think I can bring more than last year, and I'd feel the same without that 'A' on my sweater, you know? And I say that without taking anything away from Z or Muzz."

And as for the pitfalls and disappointments of last season, no need for anyone to underscore them to him, said Bergeron. He was there. He lived it. There was little to like. The big new contract in hand, he wanted to fulfill the hype, if not outperform it, only to come up short.

"That's fair, I agree," he said. "I don't need people to tell me that. I am aware of it, and I want to change. My game is to be hard on the forecheck, create on offense, finish forechecks, be good in all zones, and create plays off the forecheck. I didn't do that last year and it cost us."

Reminded that there were 17 other skaters on a night-to-night basis wearing Black-and-Gold sweaters, not to mention two goalies, he added, "I know, it's a team sport, and it's never about one guy — be it a good time or a bad time. All of us have to be better if we're going to win."

Last week, Bergeron made the seven-hour drive back to Boston, his SUV stocked with a wide assortment of music, including ample selections of rap (some of it in French; go figure) and rock-and-roll. He is back living in the Hub of Hockey, within walking distance of the Garden, where a new season is about to dawn.

For the most part, the Bruins' roster has remained static, save for a new goalie (Manny Fernandez), a key forward who is a potential Bergeron linemate (Peter Schaefer), and some added muscle up front (Shawn Thornton). The first formal workout is Friday, the day when last year officially becomes history, and the future, whatever it may be, begins to take shape.

"Always something to learn, always something positive to bring," said Bergeron, the end-of-summer sun dropping lower in the sky, in lockstep with the shrinking pile of snow and melted snowballs strewn across the parking lot pavement. "And I know we can be better." ■

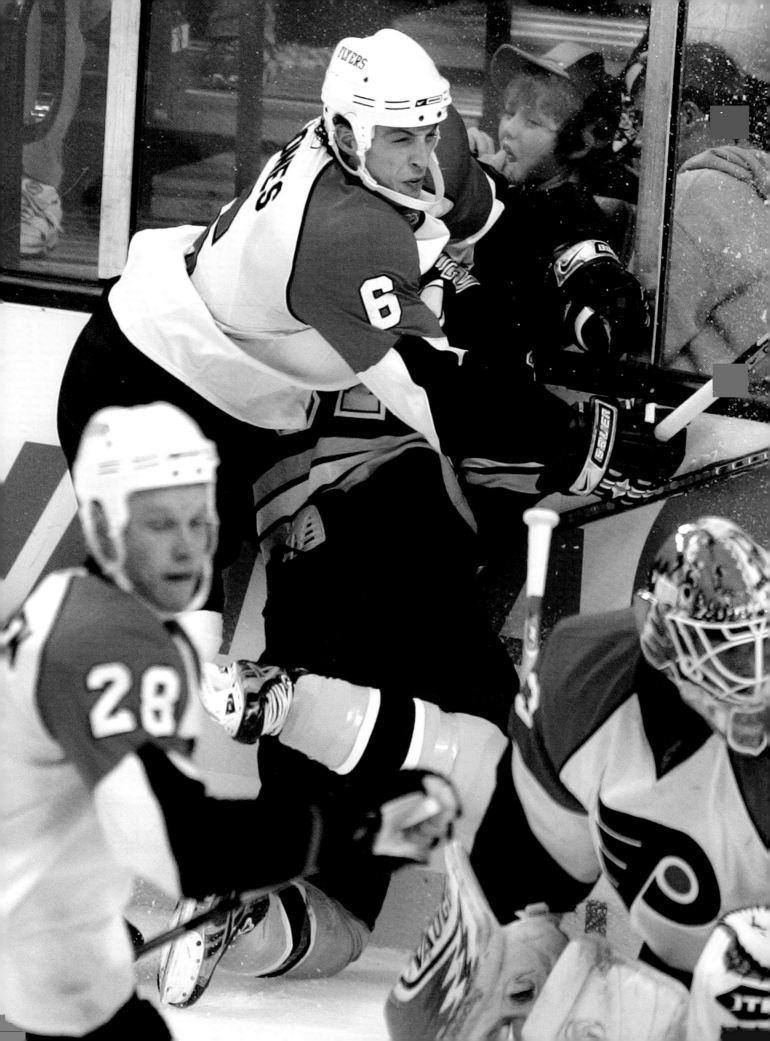

Philadelphia's Randy Jones checks Patrice Bergeron into the boards, eventually leading Bergeron to be taken out on a stretcher.

SURVIVING A SCARE

Patrice Bergeron Is Left with Concussion, Broken Nose After Big Hit

By Fluto Shinzawa | October 28, 2007

It just so happened that Sebastian Gomez, a boyhood friend of Patrice Bergeron from Quebec City, picked this week to follow the Bruins.

Gomez has been shooting a documentary on Bergeron that he is pitching to RDS, the French-Canadian ESPN equivalent.

But when the 22-year-old center crumpled to the TD Banknorth Garden ice in the first period yesterday, Gomez saw his friend, not his subject, lying unconscious behind the Philadelphia net.

For the final two periods, when all most fans knew was that Bergeron had been knocked out and transported to Massachusetts General Hospital, Gomez was on the phone with people from back home who were fearing the worst.

But when Bergeron was diagnosed with a concussion and a broken nose and reported full feeling and motion in his extremities, Gomez felt the same emotion that washed over everybody when they heard the news.

Relief.

"You see a guy lying on the ice like that, obviously it's pretty disheartening," said Andrew Ference after the Bruins' 2-1 loss. "It's obviously a relief."

Concussion and busted nose were a godsend considering the circumstances of Bergeron's injury. In the first period with the score 0-0, Bergeron was skating hard into the Philadelphia zone after a puck. As Bergeron, facing the wall,

It was a scary scene as Patrice Bergeron lay motionless, was wheeled off the ice, and eventually taken to the hospital for treatment and observation overnight.

batted the puck away, defenseman Randy Jones hit him from behind, sending the forward face-first into the boards.

Bergeron, knocked out by the hit, fell backward after colliding with the boards and was motionless on the ice with his head tilted at an awkward angle. Play was halted at 16:07 as trainers, emergency officials, and team orthopedist Dr. Thomas Gill made their way onto the ice. Bergeron's gloves and uniform were cut away. His legs were taped together and his arms were taped across his chest before he was lifted onto a stretcher and wheeled off the ice. Glen Murray told NESN between periods that Bergeron was talking as he was taken off.

Bergeron was treated at Mass. General by Bertram Zarins, the club's head physician, who reported that after initial X-rays and a CT scan, the alternate captain did not sustain a serious injury to his head or neck. Gerard Cleary and Sylvie Bergeron, the center's parents, were in attendance and traveled to Mass. General with their son. Bergeron remained at the hospital last night.

Bergeron has never been diagnosed with a concussion as a pro. He missed five games because of knee and oblique injuries last year.

"It was a really bad, bad hit from behind," said captain Zdeno Chara. "It's really tough for teammates to see one of your teammates go down like that. There's no room for that."

Jones issued a statement in the middle of the game expressing concern for Bergeron.

"Words really can't express the way that I feel right now," said Jones. "I am very apologetic for the hit and what I did. It was not intentional. It is something that I have never done before, and it is not part of my character. I am extremely sorry. I hope he does OK and everything works out for him. I wish him nothing but the best in his recovery."

Jones was called for a five-minute boarding major and a game misconduct. Jones faces a possible suspension from the league.

"I don't think that's accidental," coach Claude Julien said. "So yes, it was a dirty hit."

It was the third major incident involving Philadelphia this season. In the preseason, forward Steve Downie left his skates and leveled Ottawa's Dean McAmmond, delivering a concussion to the forward. Downie was suspended for 20 games. On Oct. 10, forward Jesse Boulerice tagged Vancouver forward Ryan Kesler in the face with a high stick. Boulerice was suspended for 25 games.

"It's almost come to the point where you have to throw the guy out. You're done," said Marc Savard. "It's just stupidity. Are we waiting for someone who can't walk anymore or something stupid like that?"

It had been a physical game before Bergeron's injury. Shawn Thornton and Philadelphia forward Riley Cote fought at 9:02 of the first period. Fifteen seconds later, Milan Lucic fought with forward Ben Eager.

"The point of hitting is to knock the other guy off the puck and change possession of the puck," said Ference. "The point of hitting isn't to hurt somebody. That's where some guys are mistaken.

"They're just going out and running around and not even caring where the puck is. You see a guy vulnerable for as big a hit as possible, they're going to take it. It's not the point of contact in our sport." ∎

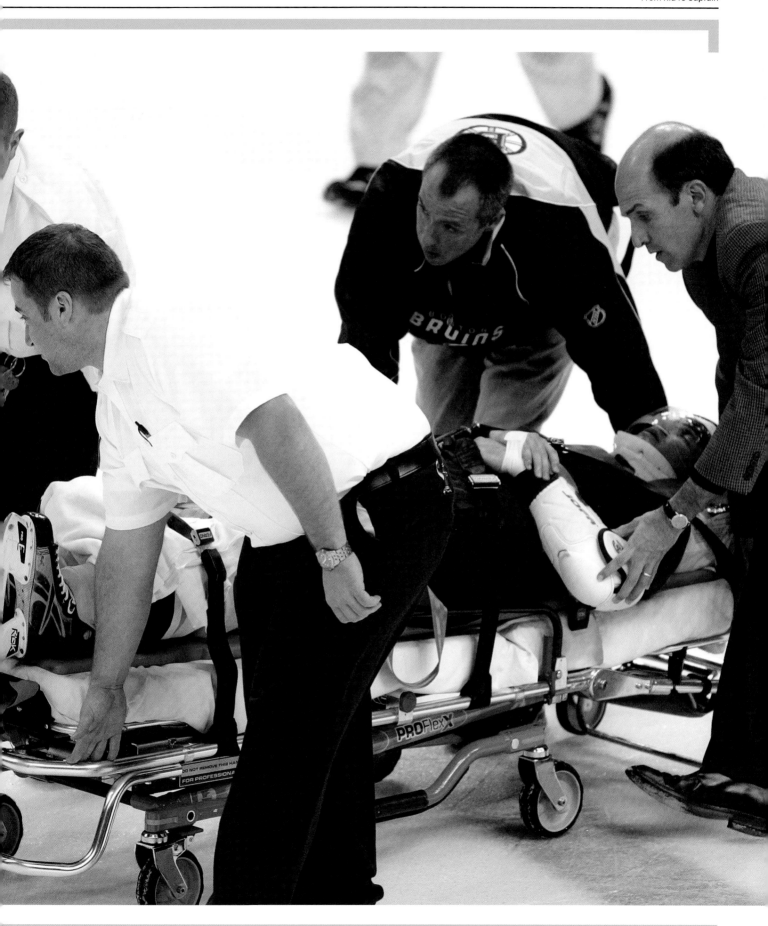

BERGERON ACHES TO SKATE

A Scratch for So Long, He's Itching to Go Now

By Kevin Paul Dupont | June 22, 2008

Patrice Bergeron wants to skate, right now, today, which isn't winning him a whole lot of goodwill with his NHL buddies back home in Quebec City who have their minds fixed on vacation and not vocation. Late June on the NHL calendar is reserved for fishing, backyard barbecues, 18 holes (minimum) of golf, and extra-extra-extra time by the pool.

Skating, or even driving by a rink, is definitely not on your average NHLer's to-do list.

"Yeah, some of the guys are giving me pretty weird looks," said Bergeron. "But I'll get some of them out there, for sure, and it will be [this] week. They know how I am, and how long it's been for me — how much I miss it."

OK, the vitals, and Bruins fans, you are going to like this:

- Bergeron's weight is up to 190, only 4-6 pounds below what it was on Oct. 27, 2007, when he was hammered into the rear boards by the Flyers' Randy Jones and left with a Grade 3 concussion and broken nose. In the weeks following the collision, his physical activity almost nil, his weight dipped to the mid-170s.

- He remains symptom-free, with no residual dizziness, nausea, or lethargy connected to what was nearly a career-ending blow. "I was symptom-free during the playoffs, too," said

Patrice Bergeron
makes his first
public appearance
in November 2007
to speak about his
physical and mental
condition after what
would become a
season-ending injury.

Bergeron. "But the doctors played the 'safe' card, and I'm glad they did. They put the human being ahead of the hockey player, and I am very thankful for that. I was grateful then, but it had been so long since I had been in the playoffs, I wanted to play — but I understood their position."

- He is working out six days per week, at a level consistent with where he trained last August in the days leading up to the start of training camp. Guided by personal trainer Raymond Veillette, he is emphasizing cardiovascular workouts, such as sprints in intervals of 15 seconds, followed by 15 seconds of rest, followed by another 15-second burst, followed by ... you get the idea. In true Bergeron fashion, he is on the attack. You expected anything less?

"I'm feeling great," said Bergeron, his voice clear and strong, exactly what one would expect of a 22-year-old who is eager to restart a career that was nearly hijacked out from under him. "I'm back doing full workouts, the same as I was doing last year, and in some ways, I'd even say I'm ahead of where I was last year. No problem."

Now all he has to do is convince some of his pals to come in from the summer sunshine, at least for a couple of hours. Bergeron routinely trains in the summer at one of Quebec City's suburban rinks, with Steve Bernier, Antoine Vermette, Mathieu Garon, Simon Gagne, and Eric Belanger, among others. As the weekend approached, he was making his calls, stating his case, hoping to persuade enough of them to resume some light on-ice workouts as early as tomorrow.

"I think they understand, you know, that I didn't get to skate much at all last season," he said. "I think they'll come. They know how much I love to play."

If they're slow to come around, Bergeron plans on taking to the sheet himself, just for shooting and stickhandling drills. Once the puck

is dropped in the preseason, it will have been some 46 weeks since he last played, and he knows how close he came to that Oct. 27 game being the last game he ever played. When he's back in September, he wants to be as game-ready as possible.

"There's our impact player," said Bruins general manager Peter Chiarelli, who opted not to replace Bergeron's salary, as allowed per the CBA, during the 2007-08 season. "When someone comes back from injury, it's like getting a player via trade."

Meanwhile, Bergeron also plans on having some added head protection upon his return. He and team trainer Don Del Negro have had a number of discussions in recent weeks with Reebok about making sure he has a helmet that fits snugly and contains some extra padding.

"The people at Reebok are willing to help me a lot," said Bergeron. "They've been great. We've talked about the extra padding in there, and also to make sure that when it's on, it doesn't move."

His next visit to Boston will be July 7, the day before the Bruins open their development camp (July 8-12) in Wilmington for draft picks and free agents. He plans to work out that week with John Whitesides, the club's conditioning guru, and will jump on the Ristuccia Arena ice before or after the kids are put through their paces.

"I'm very thankful," said Bergeron. "I've got a long career ahead of me. I love Boston, and more than anything, I want to win in Boston." ■

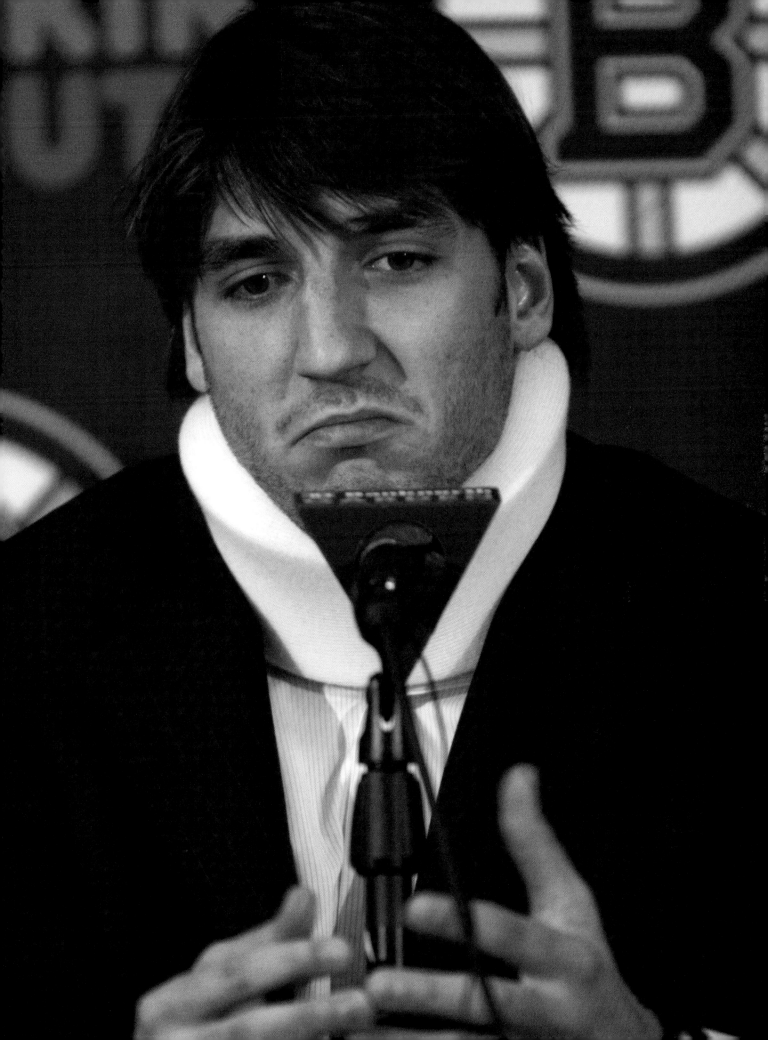

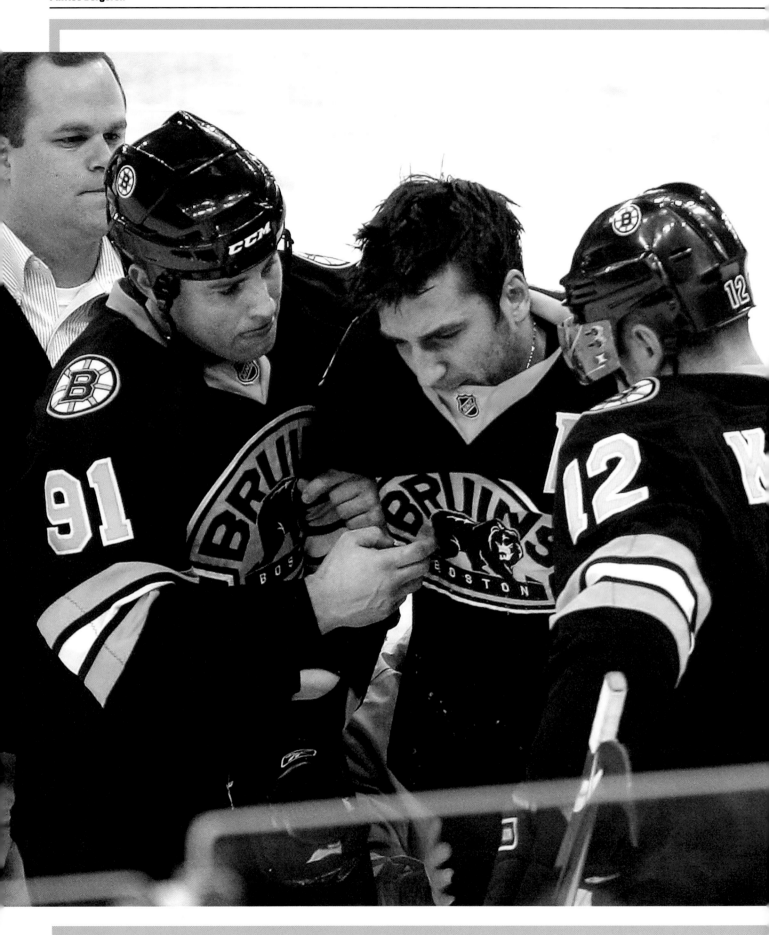

Just over a year after the hit that cost him much of a season, Patrice Bergeron's collision with Carolina's Dennis Seidenberg was another harrowing moment for Bergeron and Boston fans.

CONCERNED SILENCE

Teammates, Fans Hope for the Best for Bergeron After Scary Collision

By Barbara Matson | December 21, 2008

There is nothing so quiet as a full house gone nearly silent.

Halfway through the second period of yesterday's matinee between the Bruins and the Carolina Hurricanes, Boston center Patrice Bergeron collided with Carolina's Dennis Seidenberg in the neutral zone and dropped to the ice in a heap.

The sellout crowd at TD Banknorth Garden became hushed as Bergeron lay motionless, face down on the red line.

The other Bruins on the ice — P.J. Axelsson, Chuck Kobasew, Matt Hunwick, Shane Hnidy, and goaltender Manny Fernandez — immediately circled Bergeron as trainer Don DelNegro rushed out to attend to the center. The players then stood, or leaned over, hands on their knees, watching DelNegro work on their 23-year-old teammate.

As DelNegro used his hand to gingerly move Bergeron's neck, team physician Peter Asnis and physical therapist Scott Waugh also came out on the ice, assisted by Marc Savard. The 17,565 people in the arena seats, and 13 more on the Bruins' bench, suddenly found their hearts in their throats.

It was scarcely more than a year ago, Oct. 27, 2007, that Bergeron was knocked into the boards on a devastating hit from behind by Philadelphia's Randy Jones, suffering a Grade 3 concussion as well as a broken nose. His recovery was laborious; he missed the remainder of the season

Teammates Chuck Kobasew and P.J. Axelsson kneel next to Patrice Bergeron in concern.

and the playoffs. Back in full stride when training camp opened this season, he had four goals and 14 assists in 30 games before yesterday's, proving to be one of Boston's most valuable forwards, if not yet as prolific as he had been.

Hockey is full of bumps and bruises, but no one wants to watch a player hit the ice and not bounce right back up.

"We don't say much on the bench," said coach Claude Julien after the Bruins' 4-2 victory. "I kind of looked up to see if they were going to show the replay. I'd seen it in front of my eyes happen, but you like to look at replays sometimes — you want to see was it an elbow, was it a stick, was it a shoulder?

"To me, it was not a cheap shot by any means, it was a collision. You don't want to say much because you don't want to disrupt the bench. You want to let the doctors and the trainers just do their job and move on."

But the severity of the concussion Bergeron suffered last year — an injury that threatened his career — was the first thing everyone thought of when Bergeron spun and hit the ice, at 8:37 of the period.

"The worst thing to do is to try and think of what's really happening there," Julien said. "I'd try not to think too much and try and wait for the trainers to go and say for example if it's a stiff neck or a shoulder, or whatever. I saw him move his feet a little bit and saw him try to get up. It obviously wasn't anything near what happened to him last year."

Said Kobasew, "You never want to see that, whether it's your team or their team. The trainers got out there pretty quick and you just let them do their work. You never want to see it happen to anybody."

Kobasew, who was squeezing Seidenberg from the left side while Bergeron raced in from the right as the trio careened through center ice, said he didn't see the collision. Seidenberg's shoulder connected with Bergeron's left cheek and Bergeron, who wears a visor, landed first on his elbows, his head snapping a bit as he splayed out on the ice.

After nearly two minutes, Bergeron began to move his feet and a couple of minutes after that he was helped to his feet by Kobasew and Savard. They held Bergeron up until he got about 15 feet from the bench, when he shrugged them off and skated the final steps on his own and then walked down the runway to the locker room.

"It was [quiet] on the bench, everyone was silent," said Savard. "I turned to talk to Gino [Milan Lucic], and I felt like everyone in the rink could hear me."

"It's a tough situation," said Savard, who scored his 10th goal of the season less than two minutes before Bergeron was injured. "I think we dealt with it and we played hard."

Julien said he saw Bergeron after the second period and found him alert, but the coach nonetheless seemed a little stunned. "He said he got dinged pretty good," Julien said, "but he was speaking to me and, uh, then I took off and went and coached the third period."

Doctors told Julien they were still evaluating Bergeron and did not yet have a diagnosis. By 4:30 p.m., he was at a local hospital for further testing. ■

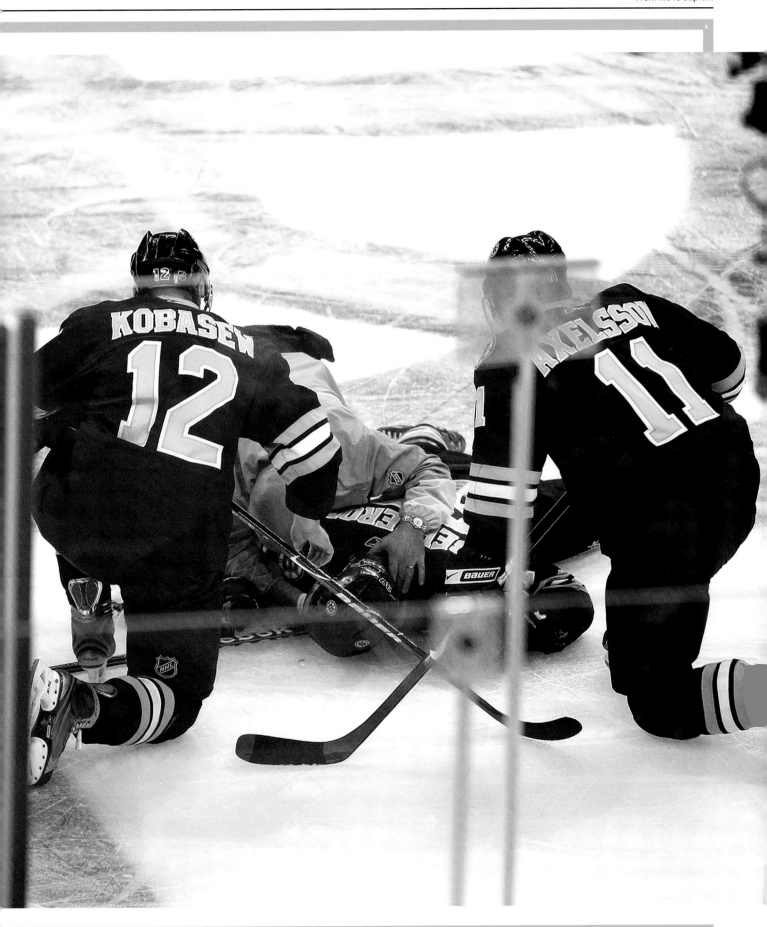

Patrice Bergeron expressed optimism about his return during the 2008-09 season just weeks after his scary collision.

BERGERON VOWS HE'LL BE BACK

Bruins Center is Feeling Better, Optimistic About Return

By Fluto Shinzawa | January 10, 2009

During the dark 10-day stretch following his Dec. 20 concussion, when he was recovering in his downtown home and experiencing some of the symptoms that plagued him a year earlier, Patrice Bergeron's psyche was as battered as his body.

It was just prior to the collision that finally, more than a year after the Grade 3 concussion that nearly ended his career, Bergeron was starting to feel like the old No. 37. He was showing off his hockey sense. He was making plays. Bergeron was playing his game — that elusive blend of in-your-face toughness with a skilled touch of elegance.

"He had more jump," said Bruins general manager Peter Chiarelli. "The game before, he had a little more jump, too. He was making plays. He was making plays with his stick. Not just on the power play. He was making plays in traffic. He looked like he was free-flowing. Certainly that game, outside of some of his performances in training camp, was his best game."

But there he was on the TD Banknorth Garden ice, laid out with his second commotion cerebrale, the cause of a shoulder-to-cheek collision with Carolina defenseman Dennis Seidenberg in the very game in which he felt at his best.

"I was more frustrated and sad, I guess, to have to go through this all over again," Bergeron said yesterday in his first public appearance since his second concussion. "There was a little fear from what happened last year. Right away when

Patrice Bergeron was helped off the ice after his injury in 2008 and he believed it wasn't as serious as the aftereffects of his 2007 setback.

the hit happened, it was, 'Geez, same thing all over again.'"

But after that initial week and a half, when the headaches, nausea, dizziness, and fatigue began to wane, Bergeron understood that his latest concussion hardly resembled the first. Last time, Bergeron was knocked unconscious. He was sensitive to light and hardly able to walk. He had to wear a neck brace.

This time, his nose wasn't broken. The hit on the jaw, explained Robert Cantu, the neurologist who consulted with him last season, would likely have caused a concussion to anyone. In fact, Cantu explained that Bergeron would have probably suffered a concussion even if he had been free of head injuries prior to the Seidenberg collision.

"I was starting to feel a lot better about my game," Bergeron said. "Then that hit happened. To go down again with a concussion is really frustrating. But it was the first week I was thinking about that. I was down and a little negative. Now that I've improved, I'm not thinking about that. I'm looking forward."

Bergeron, who is free of headaches, sees a return this season, although neither he nor the Bruins have established a timetable. So far, Bergeron (4-14-18, 57 percent faceoff winning percentage, 18:02 average ice time) has missed nine games because of this concussion.

"I'm very confident I'll play this year," said Bergeron. "It's a matter of when. That's why I don't want to put a date on it and get disappointed like I was last year in the playoffs. I've learned from that. So yes, I do think I'll be back."

Bergeron recalled that on the play, he was headed up the ice, trying to stop Seidenberg from gaining the red line before dumping in the puck. For some reason, Bergeron turned into an onrushing Seidenberg instead of hitting the 6-foot-1-inch, 210-pound defenseman straight up.

"I carried the puck out of our zone, tried to get the red line, and tried to get the puck deep into their zone," Seidenberg said. "He tried to hold the red line to force an icing. I got rid of the puck, I saw him coming, and I kind of braced myself. He must have tripped or fell into me with his jaw a little bit. It must have just caught him right on my shoulder there. Definitely strange. He tried to hold the red line. That's an everyday play. The timing was a little off, I guess, and he hurt himself."

Bergeron spent one night at Massachusetts General Hospital, just as he did last season after taking the hit from Philadelphia defenseman Randy Jones that caused his first concussion. But even as he fought through post-concussion syndrome this time, Bergeron knew the symptoms weren't as severe.

"I realized it wasn't even close to last year," he said. "I was going to feel a lot better quicker."

Approximately a week ago, Bergeron returned to physical activity, starting with five-minute workouts on the stationary bike and elliptical trainer. Most recently, he has been riding the bike for 25-30 minutes, increasing his heart rate to between 145 and 150 beats per minute, while remaining symptom-free. Bergeron will continue to jack up the intensity of his workouts to test how far he can go without experiencing headaches or nausea. He did not say when he could resume skating.

"The biggest thing I learned from last year is to take it day by day," he said. "Don't look too far ahead. If I do, I might get disappointed. If I say I'm going to skate in two weeks or one week and I don't, then I'm going to be disappointed. I want to take it day by day, follow the orders from the doctors, and try to improve. But also rest and don't try to do too much when you do feel better, because it can set you back."

While Bergeron was optimistic about his recovery and appears to be on target for a return this season, he could experience a setback or a recurrence of symptoms. There also remains worry about another concussion.

"It's obviously a concern," Chiarelli said. "That's where we are with him. He's a strong kid. Physically, he's strong. It's part of the equation now." ∎

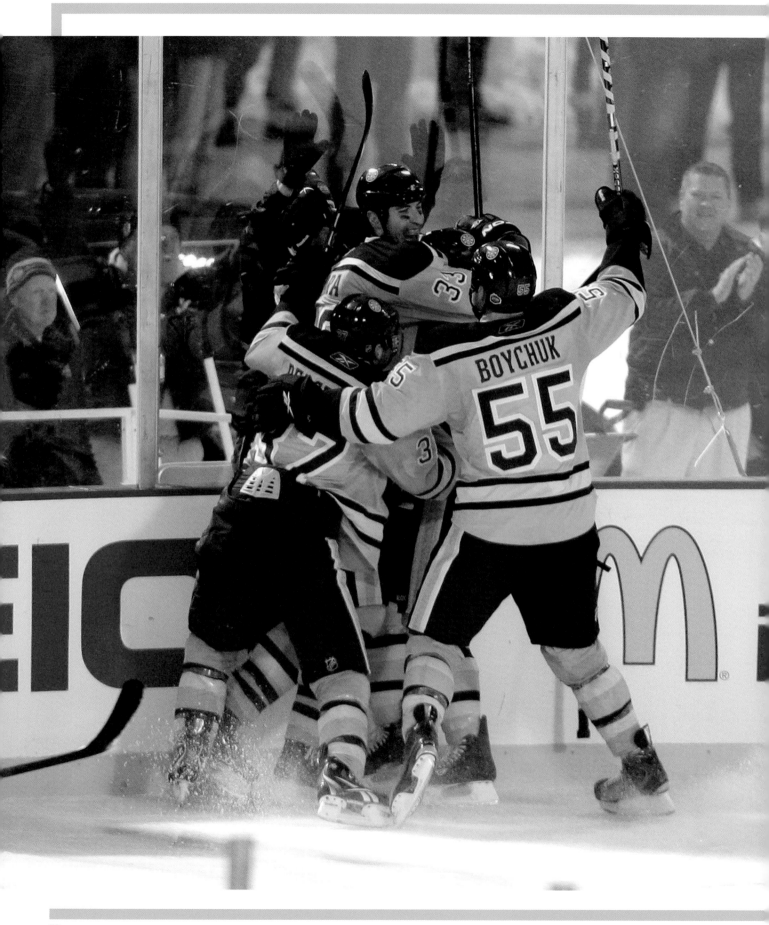

❖ BRUINS 2, FLYERS 1 (OT)

January 1, 2010 • Boston, Massachusetts

FENWAY FANTASTIC

Overtime Goal Completes a Bruins Comeback Worthy of Fenway Lore

By Fluto Shinzawa

Patrice Bergeron and his teammates mob Marco Sturm after Sturm scored the game-winning goal in overtime to beat the Flyers in the NHL Winter Classic at Fenway Park.

Per his lifetime habit as a hockey player, Patrice Bergeron looks skyward after certain plays to watch scoreboard replays, only to check himself for his mistake. Naturally, all Bergeron would see was the sky over Fenway Park.

Good thing. Had there been a roof over Fenway, it would have crumbled into powder and fluttered onto the rink like so many snowflakes. At 1:57 of overtime, 38,112 fans exploded after Marco Sturm tipped a puck past Michael Leighton to give the Bruins a 2-1 victory over Philadelphia in the Winter Classic.

"This was an unbelievable scenario," said coach Claude Julien, shedding the tan fedora he wore on the bench. "Not just the game, but looking around. This is my second one, but there's no doubt there was something special about this park that kept you in awe."

Even before the win, this had been a Disney-scripted Classic. The rain predicted earlier in the week was nowhere to be found. Puck-drop temperature was 39 degrees.

On Thursday, the Bruins scrimmaged under a shower of grin-prompting snowflakes — their families also took twirls on the Fenway ice after the practice — that had the players buzzing well into the night at their team hotel.

Yesterday, once the Flyers took a 1-0 lead at 4:42 of the second period, the sentiment was the following: Why not win to cap off the spectacle?

"It's Fenway Park. It's history. It's something you're going to remember the rest of your life,"

Boston Bruins head coach Claude Julien, left, and Patrice Bergeron stand at center ice as workers clear snow on the outdoor rink with shovels during practice at Fenway Park on December 31, 2009.

Bergeron said. "You want to be on the good side of the outcome. You want to win."

First, Tim Thomas, the goat on Danny Syvret's opening goal (the hot-headed netminder, in retribution for an uncalled interference infraction on Scott Hartnell, cross-checked the bushy-haired agitator and left his net vacant), saved the day by foiling Danny Briere twice in overtime. Then the Bruins turned to Bergeron and Marco Sturm, the duo who have played together for so long that each of their movements have become second nature.

Sturm, just inside the blue line, won a battle against Matt Carle and swatted the puck to Bergeron along the boards. In turn, Bergeron blew past Mike Richards and chased down the puck. As Bergeron turned for the net, Sturm, knowing what was coming, sprinted to the slot. On cue, Bergeron's feed arrived at the perfect time for Sturm to tip it into the net, prompting a pig-pile celebration — the Bruins swarmed into the corner just along the third-base cranny that juts into left field — that would have spilled onto Lansdowne Street had the boards not been there.

"It happened right in front of me," said Zdeno Chara, first to swarm Sturm after the winning goal. "Sturmy jumped. We all jumped. The crowd reacted. That's the best you can ask for — to be on the ice for the game-winning goal and see your teammate being happy. We were all hugging each other like we won the Cup. It was a great feeling."

The celebration, both on the ice and in the stands, was something the Bruins weren't sure they'd witness. For 55 minutes, while the Flyers were generating most of the scoring chances on Thomas (24 saves), the Bruins did little — the first-period throwdown between Shawn Thornton and Daniel Carcillo being the exception — to prompt excitement from their fans. As much natural buzz existed within Fenway, there was nothing equaling the jubilation of the home team scoring.

That all changed, finally, after Kimmo Timonen was whistled for tripping Chara in the Philadelphia crease at 16:08. On the power play, the

No. 2 unit worked their left-side half-wall play to perfection. After Mark Recchi dived to keep possession of the puck, David Krejci, from the left boards, dished to Bergeron at the point. With a hard head-and-shoulders pump, Bergeron faked a pass to Derek Morris, which left Flyers penalty killer Jeff Carter out of position, then slipped a return feed to Krejci.

"I was ready to shoot it," Krejci said. "Maybe that's why they thought I was going to shoot it and they sagged back."

A fat passing lane opened, and Krejci hit Morris with a cross-ice pass. As Morris locked and loaded, Recchi fronted Carle, planted his blade on the ice, and waited. Morris slapped a pass to Recchi, and the veteran shoveled the puck past Leighton to tie the score with 2:18 remaining.

"It kicked in when I got to the bench," Recchi said of realizing the significance of the moment. "Just excited. We got in a big pile and were screaming at each other. We got to the bench, and looking around, realizing the place was going nuts, it was a very special feeling, that's for sure."

It all came together. Thomas, having lost his cool, comes back to win the Classic on a day he fulfills a lifetime dream by making the US Olympic team. Bergeron, the comeback kid who was named to the Canadian Olympic roster earlier in the week, picks up the key assist in overtime. The fans are treated to the frozen equivalent of a game-ending home run.

And the Bruins claim 2 points.

"Winning it," said Julien, "makes everything that's happened here the last couple days even better. We had a great time [Thursday]. Our players, families, everyone enjoyed themselves immensely. Guys going back to their rooms [Thursday] night after we had a team meal, they were telling me how much they appreciated that day and how special it was for all of them and their families. When you come back the next day and win the game, you can talk about this forever. It's a great story." ∎

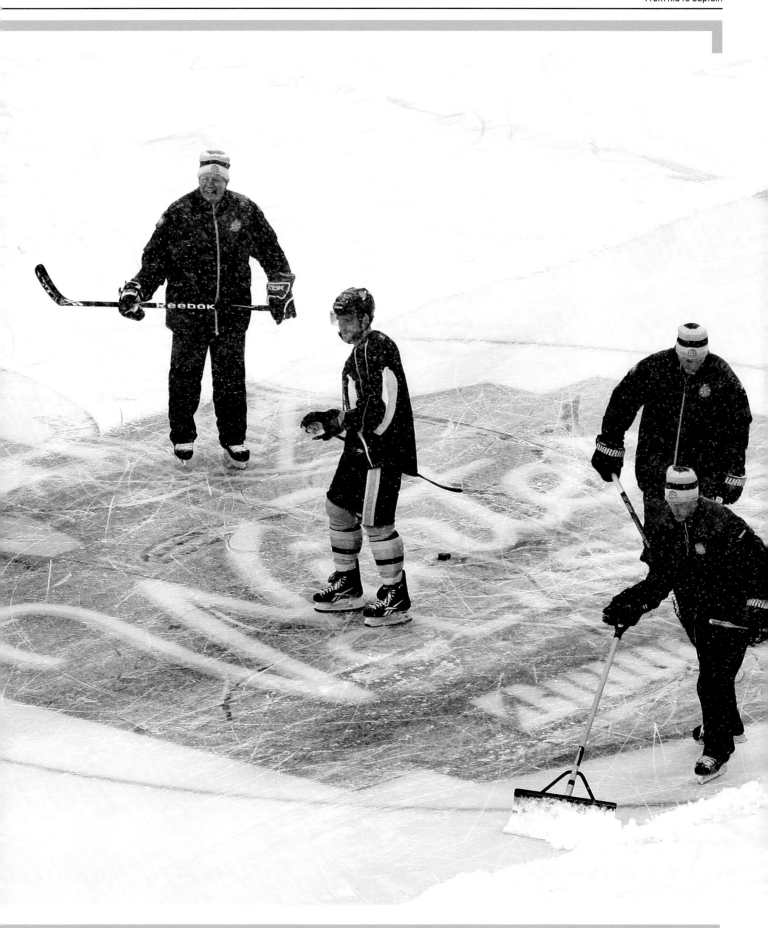

Patrice Bergeron practices prior to the start of the 2011 Stanley Cup Final against the Vancouver Canucks.

IRREPLACEABLE

Patrice Bergeron is the Centerpiece Who Keeps the Bruins Clicking

By John Powers | June 1, 2011

To appreciate all that Patrice Bergeron does you have to watch him — and only him — for an entire shift. Observe the constant motion, the abrupt changes of direction, the head swiveling like a hawk's, tracking the puck and his teammates, the instinctive sense of time and space.

"He's just everywhere," marvels rookie winger Brad Marchand, his linemate. "He's doing every little thing right. He does a lot of things that are underestimated. He plays so well defensively. He's always the first guy back in the zone, always down low battling, getting the puck up to me and Recchs [Mark Recchi] so we can go on offense. He's really leading our team right now, taking control of everything and showing the guys the way."

Bergeron may be only 25 but for the past eight years, minus the lockout season of 2004-05 and the 2007-08 campaign that was lost to a nasty concussion, he has been the mucilage that has held the Bruins' fuselage together. "There's not a night that this guy doesn't show up," says coach Claude Julien. "His solid play certainly gives not just the coaches but all of his teammates a lot of confidence. You have him out there on the ice, you know what you're going to get."

So when Spoked-B adherents spotted Bergeron on his knees in the playoff finale with the Flyers, his head befogged after a collision with forward Claude

Giroux, it was a major oh-no! moment. As in oh no, there goes the season.

Without their best centerman, the Bruins probably wouldn't be in Vancouver tonight, taking on the Canucks in the Stanley Cup Final. "He plays in every situation," says winger Milan Lucic. "When a guy like that goes down, you lose a key player on your team. We're going to need him to keep playing big and keep doing what he does."

Leading by example

What Bergeron does is irreplaceable. He logs among the most minutes of any Boston forward. He wins the most faceoffs. He's the most reliable defender up front. He plays on special teams. And he's a magician at putting the puck on his linemates' sticks. "He sees plays before they even happen," testifies Marchand, whose six postseason goals include five Bergeron assists. "I think that's what makes him such a great player. He knows where guys are going to be and he's able to put the puck in positions where they're going to get it."

Bergeron's fingerprints have been all over these playoffs. He was the chief reanimator in the Montreal series, contributing 5 points in the three victories that brought Boston back from an 0-2 deficit, then assisting on the first goal in the Garden finale. He added five more points in the sweep of Philadelphia, setting up three goals in the 7-3 road opener that got his mates up and winging. Then, in his second game back after sitting out the first two against Tampa Bay, Bergeron scored two goals, one shorthanded, to stake the Bruins to the 3-0 lead that they ultimately squandered.

"He's a guy who's leading by example, working extremely hard every shift, every game, playing against top lines," says captain Zdeno Chara. "You can always rely on him to do the right thing. He's been so solid for us, not just in the playoffs but throughout the whole regular season."

Bergeron is the linchpin of what may be the league's most eclectic line, which features the 23-year-old Marchand on the left side and the 43-year-old Recchi on the right. "We clicked right away," says Bergeron. "March brings a lot of speed, a lot of intensity and skills also and Recchs has the experience, all the little details."

What Bergeron brings is savvy, touch, vision, and relentlessness. Engaging in battle drills with him when both were coming off injuries was exhausting, recalls Andrew Ference. "Trying to cover him, trying to keep up with him and battle for loose pucks with him . . ." the defenseman says. "He's absolutely one of the most competitive and proud people I've played with or against. He's just got a determination that's so valuable to our team. He's not the loudest guy on or off the ice, doing flashy things, but he just doesn't stop."

Early success

Bergeron has been a man in motion since the day he showed up in camp in 2003, an 18-year-old from Ancienne-Lorette, Quebec, who was Boston's second-round draft pick (45th overall). Like Bobby Orr, Ray Bourque, Joe Thornton, and Lucic, he made the jump directly from juniors and ended up playing 71 games, scoring 16 goals, and tallying 39 points as the league's youngest player. "Patrice was mature at a very young age," says goaltender Tim Thomas, the only teammate who predates him.

Being thrust into the fast lane wasn't a problem — Bergeron immediately was tapped for Team Canada for the 2004 world championships and ended up with a gold medal. "When you're thrown in the ocean you've got to find a way to swim if you want to survive," he says. "That's how I learned. I went out there and trusted myself and had confidence that I could do it. But, still, I had to if I wanted to come out on top and stay there. I had to find a way."

For role models Bergeron looked to veteran

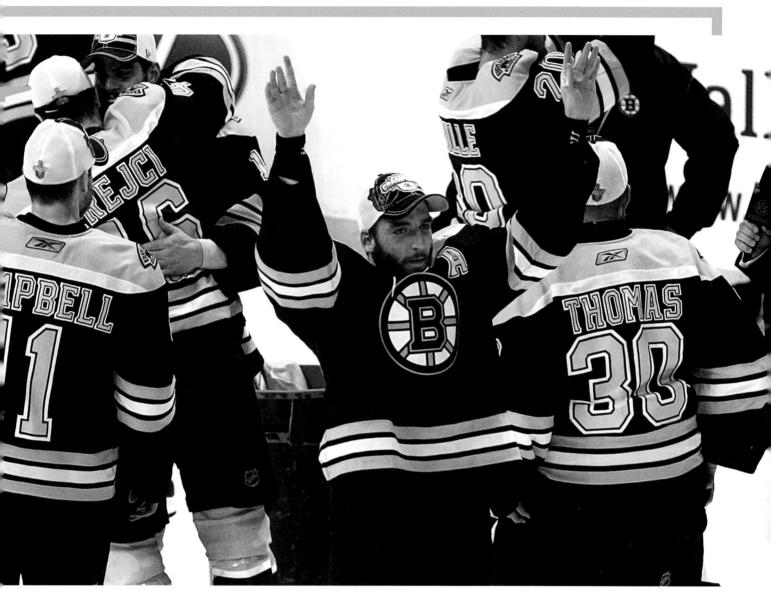

Martin Lapointe, a fellow Quebecois who invited the new kid to live with his family, and to Thornton, who'd been named captain the previous year. "He'd been there as an 18-year-old coming in and I was the 18-year-old coming in," Bergeron says. "He was so successful. The fact that he had a 100-point season, I was trying to do what he was doing."

When the NHL owners locked out the players the following season, Bergeron went to Providence to play with the Wanna-B's. Besides the chance to get another 68 games under his belt, Bergeron worked on his English and got to know the younger guys who'd soon be his teammates. The club was going to need a new crop

of leaders when play resumed, since fewer than a dozen veterans returned.

Bergeron had led by example on the ice because he felt he was too young to do it verbally in the locker room. "Obviously I was still learning," he says. "It was different for me to step up, having to talk and having to tell people way older than me what to do. I had to learn that. I feel my leadership skills have always been in me. I just had to develop the talking part of it with my English and all that."

Waylaid by concussions

Bergeron's game needed no translation. He led the Bruins in scoring in 2005-06 and was second to Marc Savard

Patrice Bergeron emerged as a true star in the NHL, on and off the ice.

in 2006-07. Then, just 10 games into the 2007-08 campaign, Flyers defenseman Randy Jones slammed into Bergeron from behind, breaking his nose and giving him a Grade 3 concussion that ended his season. "I knew it was going to take awhile, but maybe not that long," he says. "I really wanted to come back and I thought I could do it, that it was just a matter of time. I stayed positive. I did have some down time. I did have some setbacks. I had no clue how long it would take. I stayed with it, but it was hard."

Bergeron had played only 31 games the following season before he was clocked by future teammate Dennis Seidenberg in a Garden match-up with Carolina and missed more than a month with another concussion. What he learned was to savor each shift as if it would be his last.

"That's what opened my eyes the most," Bergeron says. "You've got to appreciate and say thank you to each and every day and every practice and game. It's my passion, it's my sport. I knew that before but [the concussions] got me to realize that it's really what I want to do. So I try to do that in life as well."

Since Savard was sidelined for the season in February with his second head shot, Bergeron has texted him multiple times each week. And he has developed a close relationship with Matt Brown, the Norwood High hockey player who was paralyzed after breaking his neck in a game a year ago January.

"I've tried to stay in touch with him," says Bergeron, who visited Brown at the rehab center two months later when the Bruins were in Atlanta. "I saw him just before the playoffs. He seems to be doing better, staying positive. Being patient is hard but it's the main key with those types of injuries. In his case, he's doing awesome. The way Matt carries himself for his age, the things he says, is amazing."

Both men have come to understand how quickly a physical game played in an unforgiving venue can turn life upside down. Though Bergeron's third concussion was mild, it still was worrisome. But when he returned for the third game of the conference finals, Bergeron played his usual game. "He wasn't cautious, he was confident," said Julien. "He knew he felt good and he went out there and played like nothing happened."

It was a calculated risk, but the reward is exceptional. Bergeron already has three of the planet's most significant trophies on his résumé — both the world and world junior titles and the Olympic gold medal that he won in Vancouver last year. "It was amazing," he says. "You could feel the whole country was behind us."

This time it's merely a whole city, but every Bostonian would gladly swap all the gold at Olympus for Lord Stanley's mug. And should the Bruins win it, Bergeron's name should be engraved front and center. ∎

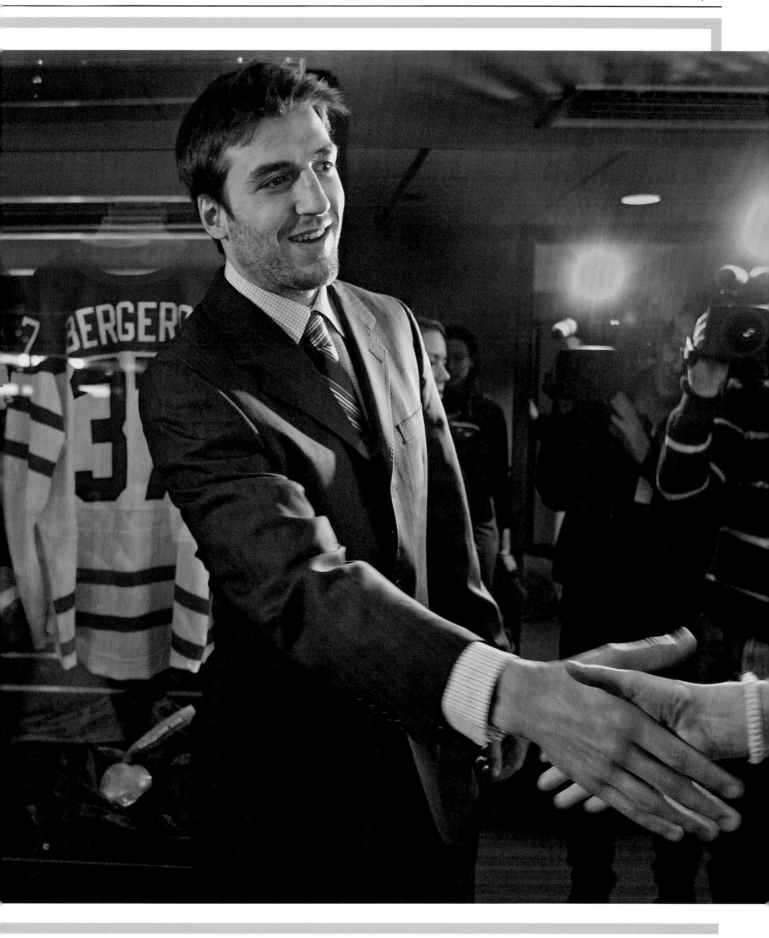

❖ BRUINS 4, CANUCKS 0

June 15, 2011 • Vancouver, British Columbia

Patrice Bergeron celebrates after scoring a goal to put the Bruins up 3-0 in the eventual 4-0 win in Game 7 over the Canucks.

BELIEVE IT!

Bruins Overtake Canucks in Game 7 to Claim Stanley Cup

By Fluto Shinzawa

For too long, hockey has been a punch line in Boston.

While the Red Sox, Patriots, and Celtics lifted their trophies and rode in their Duck Boats, the Bruins were the perpetual jokes — Charlie Brown, Larry Fine, and Bozo wrapped into one.

Hockey is cool again.

In Boston, it used to be that hockey was an afterthought even before the Harvard whizzes picked up their pencils for final exams. This time around, weeks after the last student piled his beanbag chair into the back of mom's SUV, the Bruins played on.

Now, after a 4-0 throttling of the Canucks at Rogers Arena, it will be winter for a while. The boys of pucks and pluck kept the ice frozen until well after the tulips sprouted and the Swan Boats returned to the Public Garden. Only the air leaking from Roberto Luongo's tires could melt the ice now.

"Just so much pride," Daniel Paille said as he stood on the ice after the win. "I'm so proud of everybody. I guess proud is the word."

For the first time since 1972, players with spoked-B's on their chests raised the Stanley Cup over their heads. And after seven games in the final, seven in the previous round, and seven in

As he rides on a duck boat with teammates and the Stanley Cup, Patrice Bergeron tosses a souvenir ball to the fans along the left field line at Fenway Park.

the first series, the Bruins felt every ounce of the Cup's heft.

"It was actually pretty heavy," said Dennis Seidenberg. "You get weak during the playoffs. It was pretty heavy."

There is nothing light about the Cup. It is Clarence Stanley's greatest gift, a picture-perfect symbol of what hockey is all about. The Cup is not a dinky trophy like the ones baseball and basketball players lift with as much effort as it takes to palm a BlackBerry. Even a strongman like Zdeno Chara, after first hoisting the Cup, leaned back because of its weight.

The Cup takes work. For the Bruins, it was about 82 regular-season games. Then 25 more in the playoffs. And an effort from the first man on the roster — Tim Thomas, the Conn Smythe Trophy winner, certainly counts as No. 1 — to the bottom rung.

Last night, the Canucks charged out of the starting blocks with the ferocity of Usain Bolt. They nearly bullied the Bruins out of the building with a ferocious forecheck, speed to the puck, and a wave-after-wave approach on Thomas.

When it came time for the Bruins to push back, they didn't look to their star players. Instead, they leaned on their plumbers.

Paille, Gregory Campbell, and Shawn Thornton held the fort. They took three of the Bruins' five first-period shots. They hemmed the Canucks in their own zone. They belted everything in sight.

And because of that, the Bruins found their game, grabbed a 1-0 lead — Patrice Bergeron one-timed a Brad Marchand dish from the slot at 14:37 — and ultimately fell into their rhythm.

"They were unbelievable," Seidenberg said. "They battled hard to give us energy every time they were out there. They were getting hits. They were forechecking hard. For them to give us that breather and that extra energy, it was great."

Patrice Bergeron kept the celebration going with the Stanley Cup as the 2011-12 season got underway.

There is not much pretty about Boston's game. It relies on smart decisions with the puck. Accurate placements of dump-ins. Heavy wall work. Suffocating forecheck and a relentless cycle.

It was beautiful.

Marchand made it a 2-0 game at 12:13 of the second. On the penalty kill, Bergeron fought off a Christian Ehrhoff backcheck (there was a delayed penalty on the play) and muscled a shorthanded goal through Luongo to bump it to 3-0.

When the Canucks pushed in the second and third, the Great Wall of Thomas stood tall to respond. Thomas stopped 37 shots in yet another sparkler. Marchand added an empty-netter at 17:16 of the third. All that was left was the celebration.

After the win and before the Cup was wheeled onto the ice, the Bruins hugged everybody in their sights. Chara, one of the roster's two building blocks (Thomas being the other), spotted general manager Peter Chiarelli, his former boss in Ottawa. Chara curled his 6-foot-9-inch frame around Chiarelli, the team's architect, until the GM was engulfed in the captain's hug.

Soon after, Chara found something better to put his hands on.

"I can't describe it. I still don't believe that we're here," Chiarelli said. "Maybe tomorrow at some point, I will. It was nice to hoist it. It was really nice to see the other guys hoist it. That was something special."

The Bruins reached into many wells for inspiration. They wanted to win the Cup for Nathan Horton, their go-to right wing who suffered a series-ending concussion in Game 3.

Horton didn't play, but he touched the game even before it started. Approximately two hours before puck drop, Horton grabbed a bottle full of water from Boston, stood on the bench, and poured its contents onto the Rogers Arena ice.

After the win, Horton hit the ice in full gear to lift a trophy that belonged to him just as much as it did the rest of his teammates. It was no coincidence that, in a nice touch by the hosts, "Dirty Water" blared over the speakers as the Bruins celebrated on the ice.

The Bruins wanted to win it for 43-year-old Mark Recchi, who played in his final NHL game. They wanted to win it for Thomas, the former scrub who couldn't find an NHL job. They wanted to win it for Bergeron, the career Bruin once believed to have suffered a life-threatening injury.

They won. They won all right.

They won it for themselves, their city, and their long-suffering fans. This is a franchise once defined by too many men, Petr Klima, and the 2010 gag job against Philadelphia. The eight-spoked B was a brand caked over with grime for 39 years.

But now the Bruins have a silver Cup. It comes with plenty of polish. The spoked-B now gleams bright. ∎

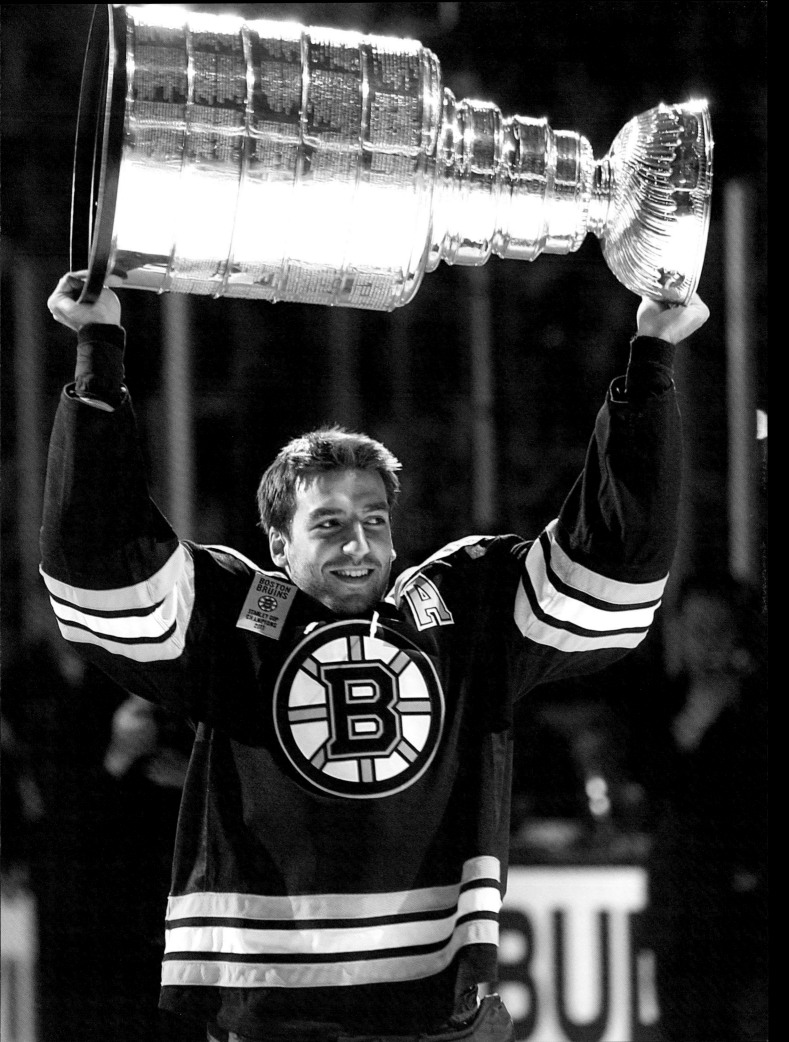

DYNAMIC DUO

Bergeron, Marchand at Center of Stanley Cup Comeback

By Cam Tucker | June 16, 2011

Forget the 1-2 punch of the Sedin brothers; how about the Patrice Bergeron and Brad Marchand combination?

Bergeron, a gold-medal winner with Canada at the 2010 Olympics, and Marchand, a two-time gold-medal winner for Canada's national junior team in 2007 and 2008, brought that same championship-caliber hockey to the Bruins last night in a 4-0 Game 7 victory over the Canucks in the Stanley Cup Final.

It's no contest which championship means more.

"That doesn't compare," said Marchand of the world junior championships. "This is such a grind and such a battle and to be here and go through it for the whole year, over 100 games, it means so much more than just a few games."

Stories will be written about Tim Thomas. And deservedly so. But at the center of the sixth Stanley Cup in franchise history were Bergeron and Marchand, who each scored two goals last night.

Bergeron, as is his style, deflected credit.

"We couldn't do it without everyone on the ice and also off the ice," said Bergeron. "Going down, 2-0, against Vancouver, it was a tough road to come back."

If you believe in omens, Marchand was born May 11, 1988, which would be 16 years to the day the Bruins won the 1972 Stanley Cup, their last

until last night.

In the fury of the celebration, the Bruins' good-luck charm found time to share an emotional embrace with his family.

"It's so surreal right now," said Marchand. "You skate around and lift that Cup up, you can't even believe it. You work your whole life for it and for it to be right there, it's unbelievable."

Believe it, Boston.

The two linemates were the quick-strike jabs to the Bruins' knockout punch, supplying all the offense the champs needed.

Bergeron opened the scoring at 14:37 of the first period and took the Canucks fans out of the game. Rogers Arena went silent.

He was the beneficiary of some incredible work along the boards by the shifty Marchand, who fed his linemate with a scintillating cross-ice pass.

Bergeron made no mistake, burying a one-timer past Canucks goalie Roberto Luongo, who barely flinched on the play.

But the duo wasn't done.

Marchand gave the Bruins a 2-0 lead, a commanding one considering the way Thomas was playing, on a wraparound that barely squeaked over the goal line at 12:13 of the second period.

Pretty? Hardly.

But it counted. And even though 27 minutes of hockey remained, it looked to be the nail in the coffin.

The Canucks looked disheveled. Their fans slinked into their seats.

Bergeron provided another blow, a shorthanded goal with 2:25 left in the second. It was an effort that exuded the will to win.

Given a partial breakaway from his blue line, Bergeron drove hard to the net, outworking Christian Ehrhoff and practically pushing the puck past Luongo.

"We wanted to come in and be a difference-maker," said Marchand. "We knew we had to step up in this build-ing. It's very tough to play here and we always wanted to go out and work hard and leave it all on the ice."

The Canucks couldn't regroup, and the two Canadians who have tasted international success finally got their hands on hockey's biggest prize, the Stanley Cup.

"I'm going to kiss it," said Bergeron. "I'm going to share it with my family and obviously first and foremost with the city of Boston and the Boston Bruins."

As this series wore on, it was the likes of Bergeron and Marchand, among others, who picked up for the fallen Nathan Horton, who was knocked out of the series with a concussion in Game 3.

Losing the first two games of the Stanley Cup Final to the NHL's best team in the regular season is but a memory.

Bergeron put it best: "It's tough to soak everything in, but at the same time, we've worked so hard. We believed in us that we could do it and we got the job done." ∎

❖ BRUINS 5, MAPLE LEAFS 4 (OT)

May 13, 2013 • Boston, Massachusetts

BACK FROM THE BRINK

Brad Marchand (63) and Tyler Seguin (19) celebrate with Patrice Bergeron after his winning goal against the Maple Leafs, sending the Bruins to the Eastern Conference Semifinals.

Bergeron and Bruins Stun Maple Leafs with Late Game 7 Comeback

By Fluto Shinzawa

The Bruins were trailing the Maple Leafs in the third period, 4-1. They had 11 minutes left in their season. Their fans at TD Garden were rightfully giving them the business.

"To be honest, I kind of thought we were done," said Dougie Hamilton.

On the bench, the Bruins dipped their heads. They were approaching that time and situation when all that was left was to honor the game, play it the right way, and send the Leafs off into the second round with the respect they deserved.

"It was tough being on the bench, getting booed, looking up at the time clock, and watching those seconds count down," Brad Marchand said. "But after [David Krejci's] line got that first one for us and started to climb back, you could

see the emotion on the bench. Guys started to believe. That's what we needed."

Belief is a funny thing. It can transform a dead-leg team to one that cannot be stopped. The Leafs, winners of Games 5 and 6, were in command. But in a span of 9:51 in the third period, the formerly stone-handed Bruins poured three pucks behind James Reimer to send the game into overtime.

Once there, Patrice Bergeron popped in the winning goal at 6:05 to give the Bruins a 5-4 win before 17,565 at a quivering Garden. The battered Bruins — they are down three defensemen in Dennis Seidenberg, Andrew Ference, and Wade Redden — will play the New York Rangers in the second round.

"Pretty crazy," said Milan Lucic, the powerhouse who helped keep the pressure alive with a six-on-five goal at 18:38 of the third. "I don't think I've ever been part of a game with anything like that."

The four-goal outburst — Nathan Horton at 9:18 of the third, Lucic with 1:22 remaining in regulation, Bergeron at 19:09 of the third, and Bergeron in OT — not only extended the Bruins' season. It promised that this current template will remain intact for at least another round.

Had the Bruins slinked out of the playoffs as losers of three straight to the scrappy Leafs, it's possible that the higher-ups would have taken a sledgehammer to the roster. Players would not have been re-signed. Others would have been traded. Coach Claude Julien might have been shown the door.

All those thoughts flooded into Lucic's head when the Bruins were down, 4-1. Lucic was probably not alone.

"You're looking at the clock wind down with half a period left and you're down 4-1," Lucic said. "You start thinking to yourself, 'Is this the end of this group here?' Because it probably would have been if we didn't win this game."

The singular dilemma with this year's group is its split personality. The Bruins showed no mercy in their 4-1 Game 1 punishment of the Leafs. They were resilient in the 4-3 overtime win in Game 4.

But they were equally meek in their back-to-back losses in Games 5 and 6 to gag away a 3-1 series lead. They scored just one goal in each loss. Reimer squirted out fat rebounds in both games. The Bruins never showed the will to plunge into the dirty areas in pursuit of those pucks.

It was the same story in Game 7. The Bruins came out roaring in the first. Matt Bartkowski slipped a wrist shot past Reimer at 5:39 to give the Bruins a 1-0 lead.

But the Leafs counterpunched with four straight socks. Cody Franson down low on the power play. Franson again from the right point. Phil Kessel on the rebound. And a Nazem Kadri tuck-in of a Kessel rebound at 5:29 of the third to seemingly send the Bruins in search of their golf clubs.

At that time, the 3-1 series lead was an afterthought.

"I'm a tired coach. I can tell you that much, trying to really find a way to get these guys to give us what we want out of them," Julien said. "We make it tough on ourselves. We're being honest here. Not being able to close it out in Game 5, we've had trouble. We've always had trouble with killer instinct. That's maybe a fault of ours. But the strength of ours is the character you saw tonight."

The comeback started at 9:18. Suddenly, the Bruins decided to play their game: heavy, physical, intelligent, relentless. Lucic wheeled around the net and connected with Horton in front for a snap shot to make it a 4-2 game.

With Tuukka Rask off for an extra skater, Lucic continued the rolling rally. Reimer punched out a steaming Zdeno Chara slap shot. Lucic, positioned in front, jammed in the rebound at 18:38.

With Rask off once more, Chara parked himself in front of Reimer. Chara shoved Dion Phaneuf out of the way. Reimer was staring into an eclipse. When Bergeron released a long-distance shot, all Reimer could see was a 6-foot-9-inch wall.

Just like that, the game was tied. The Garden pulsed.

In overtime, Tyler Seguin did the right thing. Seguin went into an area where he barely placed his skates in the six previous games: the front of the net. Bergeron had ripped off a shot that Reimer stopped. Seguin pursued the rebound, en-

gaged Jake Gardiner, and kept the play alive. A second later, Bergeron rapped the puck past Reimer.

After the celebration, the Bruins lined up at center ice. They proceeded to participate in a turtle-slow handshake line. The Bruins made sure to congratulate the Leafs on their first-round effort. The hands they shook resembled their own from 2007-08 when they took the heavyweight Canadiens to Game 7 in the opening round.

"What could have been disastrous tonight ends up going in our favor," Lucic said. "We've got to build some momentum off that. Lots to look forward to, and just happy to get past this round, which was another tough round. Hopefully we can keep it up." ∎

❖ BLACKHAWKS 3, BRUINS 2
June 24, 2013 • Boston, Massachusetts

Patrice Bergeron fought through a litany of injuries in the Stanley Cup Final but couldn't get the Bruins over the hump against the Blackhawks.

WARRIOR

Patrice Bergeron Fights Through Injuries in Deciding Loss

By Michael Vega

He did not score a goal, nor was he credited with an assist. He had contributions, but they weren't quantifiable on a score sheet.

No, what Patrice Bergeron gave his teammates was immeasurable, intangible, and inspirational when he simply laced up his skates before the Bruins' 3-2 loss in Game 6 of the Stanley Cup Final on Monday night at TD Garden.

It was, after all, only two nights before, in a gut-wrenching 3-1 loss in Game 5, that the Bruins' alternate captain — universally regarded as the heart and soul of the Black and Gold — left the United Center in an ambulance.

After skating just two shifts totaling 49 seconds of ice time in the second period of Game 5, he was taken to a local hospital to take inventory of a litany of injuries that threatened to sideline him for Boston's last stand on its home ice.

Initial reports stated that he had suffered an injury to his spleen. Later it was reported he had suffered a rib injury.

"He's a warrior," marveled teammate David Krejci. "And he loves the team."

Bergeron skated 24 shifts in 17:45 of time on ice, had his only shot attempt blocked, dished out two hits, and won five of his 11 faceoffs to help the Bruins win the battle of the dot, 36-28.

Bruins coach Claude Julien tried to protect Bergeron, telling an inquisitive media only what he could about his injuries, which was very little.

When Julien was pressed after Game 5 to give a general vicinity for Bergeron's injury —

Patrice Bergeron gestures toward a broken rib on his left side as he talks with reporters in the team locker room in the week after the Stanley Cup Final loss. Bergeron played through multiple injuries, including a broken rib, separated shoulder, and hole in his lung.

upper or lower body — his reply wasn't far off the mark when he replied, "Body."

Bergeron, himself, was reluctant to disclose the nature of his injuries. But when he saw how he might slight those media members in the room Monday if he waited to reveal his staggering injuries, he decided to come forth with their true nature.

"I know there's some media that might not be there Wednesday," Bergeron began before dropping his bombshell. "So I had a broken rib, a torn cartilage and muscles, and I had a separated shoulder."

How did he manage to play through it all?

"Ah, well, the shoulder was tonight," Bergeron said, matter-of-factly. "I had a lot of help from the medical staff."

The presence on the ice of Jeff Bauman, who overcame his life-threatening injuries at the Boston Marathon finish line to help identify the attackers, was inspirational when he served as the honorary banner captain during pregame ceremonies.

But it was the presence of Bergeron that inspired the TD Garden crowd of 17,565 to erupt in a loud roar when a behind-the-scenes glimpse on the video screen caught Bergeron, in full uniform, standing against a wall in the hallway leading from the Bruins' dressing room to the ice.

"To have him in our lineup tonight was a bonus," Julien said. "And again, there was nothing that was going to stop this guy from getting in our lineup. That's why I can't speak enough about how proud I am of our players, because of things like that.

"He wasn't going to be denied that opportunity no matter what."

While he couldn't say when he injured his shoulder, it might've happened on his first shift when he slammed into the boards on an attempt at a hard check.

"It's the Stanley Cup Final, everyone's banged up and everyone wants to help the team,"

Bergeron said, when asked how badly he wanted to return for the third period of Game 5.

"I couldn't do that in Game 5 and it was mostly because they were worried about my spleen being hurt, and that's why we had to go to the hospital.

"Everything was fine. It was mostly the ribs, the muscles and the soft tissues.

"Obviously, I would've liked to stay in it, but I was going through a lot of pain."

At the end of the night, everything ached.

But his broken ribs, torn cartilage, and separated shoulder did not produce nearly the same pain as watching the Blackhawks hoist the Stanley Cup in Boston.

"It's tough to put words to describe how we're feeling right now," said Bergeron.

"You work so hard to get to this point and to give yourself a chance to get the Cup and you feel like you're right there and you have a chance to force Game 7 and, definitely, it hurts." ■

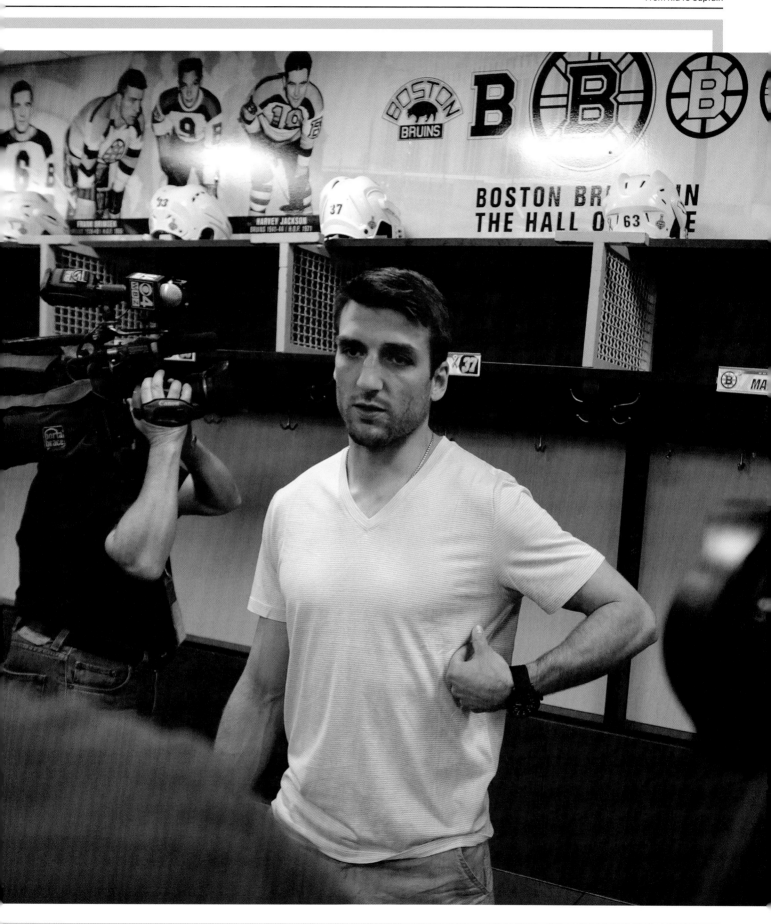

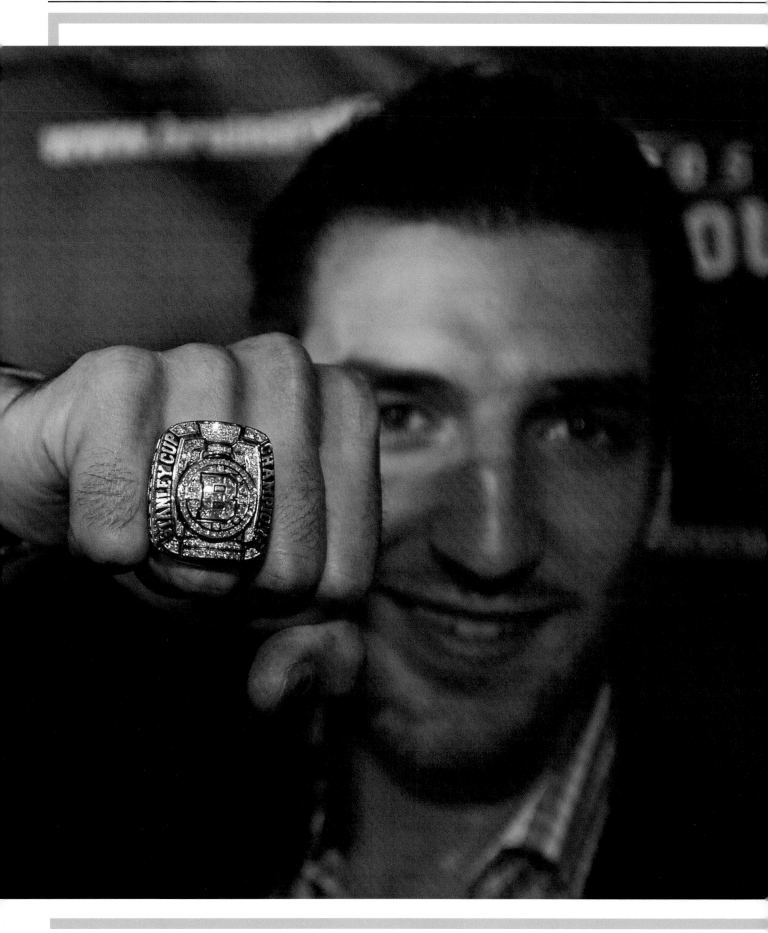

From a late bloomer to hockey in his native Quebec to stardom in the NHL, Patrice Bergeron came a long way to earn champion status.

PASSIONATE

From His Earliest Days in Quebec to His Rise in the NHL, the Bruins Star Has Never Failed to Surprise

By Kevin Paul Dupont | April 25, 2014

The weeks went by, fall's chilled pastel giving way to winter's frozen white, another hockey season unfolding throughout puck-crazed Quebec. Sylvie and Gerard were patient, content that their 5-year-old son, Patrice, cared only to crawl and sit inside the net, dotting around the ice on all fours as the other kids took their first strides inside cozy Arena Jacques-Cote.

"I assure you," recalled Sylvie Bergeron-Cleary, the mother of perhaps the top two-way player in today's National Hockey League, "of all the kids out there, he was the only one not skating."

Patrice Bergeron's slow entry into the sport that became his fame and fortune lasted some three months. Twice a week, Sylvie and Gerard made the 20-mile round trip to the arena in Sillery, with an eager Patrice in the back seat.

When would Patrice finally take a coach's hand, or grab onto one of the chairs the other kids used, propped up like penguin hatchlings?

"And finally, one day in December, he stood up in the net and started skating," Sylvie said. "He turned to us, he smiled, his eyes lit up and he waved to us. We were stunned."

Now a 10-year veteran with the Bruins, Bergeron continues to surprise with his accomplishments, almost a quarter-century after those early days in the arena at the edge of the St. Lawrence River.

As the Bruins enter game five Saturday af-

Often the center of attention, Patrice Bergeron's passion for the sport has always been unique.

ternoon in their series against the Detroit Red Wings, the 28-year-old center has completed a season in which he scored 30 goals (tied for the team lead with Jarome Iginla) and cobbled together a career-best 13-game scoring streak that included 11 goals and 17 points.

Long considered a dominant defensive forward and among the NHL's premier face-off specialists, Bergeron late this season emerged not only as a consistent offensive threat but also a Hart Trophy candidate for league MVP. He is not favored to win — Pittsburgh's Sidney Crosby is the likeliest candidate — but he assuredly will draw some votes.

It's all part of an increasingly expanding and impressive portfolio that has seen the persevering, understated Bergeron thrive despite a number of daunting physical knocks, including multiple concussions in recent years and, more recently, a collapsed lung suffered in last year's Stanley Cup Final.

A Bruins alternate captain and one of the most respected voices in the locker room, he owns one Stanley Cup, a pair of Olympic gold medals earned with Team Canada, a Selke Trophy as the NHL's top defensive forward, and another gold medal earned with Canada's world junior team.

Bergeron, the kid who once had his parents wondering whether music and not hockey could be his future, these days is hitting all the right notes.

"Hockey's his passion — it has always been his passion," recalled Bergeron's mother. "He was, I think, 10 years old when he was taking piano lessons. The instructor thought he was talented. Then one day he came home and said he wasn't going back."

The issue, recalled Sylvie Bergeron-Cleary, was that the music instructor suggested to Patrice that he should give up hockey to play piano. It was a brief conversation.

"All done," she recalled, still amused. "He never went back."

Street hockey days

Sylvie and her husband, Gerard Cleary, long a member of Sillery's department of public works, have two sons, Patrice and Guillaume, who is nearly two years his brother's senior. Guillaume played hockey until age 16 and moved on to concentrate on academics. He is a graduate of the city's Université Laval and is employed by the Province of Quebec as a workplace health and safety inspector.

Both Sylvie and Gerard grew up in Sillery, the town where Patrice eventually learned to skate, only 3-4 miles south of Quebec City's postcard downtown district. According to Sylvie, she played hockey for one year at age 14, a member of what was the first all-girls team in town. Gerard, like many Quebec native sons, played into young adulthood.

"He was a goon," offered Guillaume, flashing the trace of a subtle smile, nearly identical to that of his younger brother.

"He wasn't a goon!" objected Sylvie.

"Well," added Guillaume, a trace of a smile still in place, "that's what I've always heard."

The Bergeron-Cleary family lived in Charny, just over the Pierre Laporte Bridge, about 10 miles south of downtown Quebec, in the days when Patrice first learned to skate. Because of their age difference, the two boys rarely played on the same team, though they constantly played street hockey in front of the family's small, tidy home on Rue de L'Etourneau.

"Those are my best memories of playing with him," recalled Guillaume. "We were out there all the time."

When the boys weren't outside playing hockey, mused Sylvie, they carried the game inside, to the basement.

"We had a freezer down there," she recalled, shaking her head at the recollection of flying pucks. "All dented."

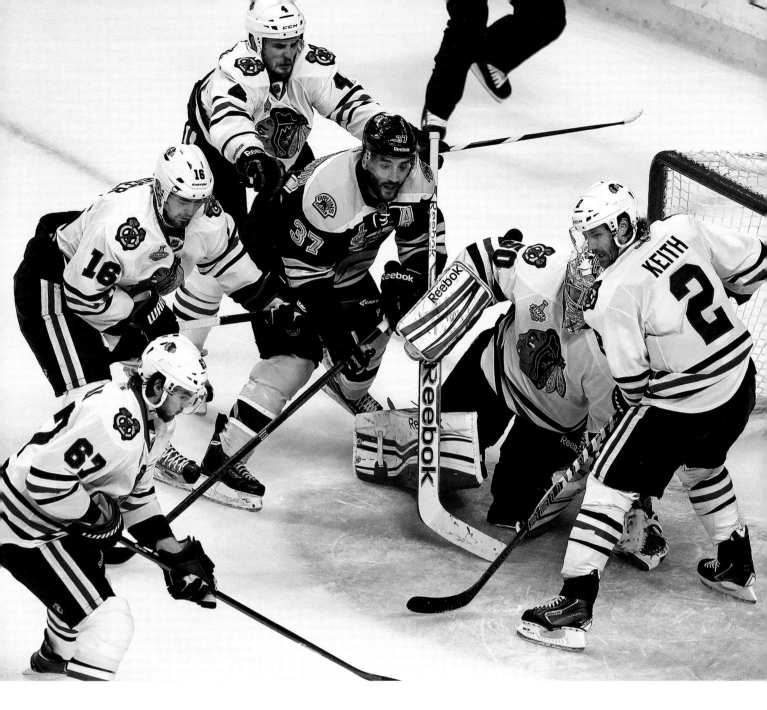

Student of the game

Guillaume and Patrice still play hockey together when Patrice returns for the summer. Patrice and wife Stephanie live in Saint-Augustin-de-Desmaures, a short drive from Sylvie and Gerard, in the same town along the St. Lawrence River where Patrice attended Seminaire Saint-Francois, a co-ed Catholic high school.

Patrice's backyard now includes his own rink, with boards and artificial surface, ideal for the Bergeron boys to return to their street hockey roots each summer.

"Usually we play together, one-on-one," said Guil-laume, his recreational time restricted by a full-time job and the joys of fatherhood (son William is two months old). "If I am not out there, Patrice is, practicing one-timers, quick wrist shots."

According to Guillaume, his brother is the same determined worker in the summer as he is during the NHL season. Patrice, he said, takes no more than two weeks of vacation, then returns to workouts, typically under the tutelage of trainer Raymond Veillette at Université Laval for strength conditioning and dry-land exercises.

Along with the backyard workouts, he'll sometimes

Patrice Bergeron hoists the Stanley Cup in front of the hometown fans at TD Garden before the 2011-12 season opener.

rent ice for an hour at a time to work on skating and shooting. He also shares ice time with a group of NHL players from the area, including Steve Bernier (New Jersey) and Antoine Vermette (Phoenix). Bernier is a fellow alum of Seminaire Saint-Francois, where both of their NHL sweaters hang proudly in a display case inside the school's Complexe Sportif.

Luc Savoie, the school's athletic director the last 18 years, recalled the "polite, quiet, respectful" student-athlete that Bergeron was in his Seminaire days, Grades 7-11.

"Always in good humor," added longtime Saint-Francois teacher Mark Berthiaume. "A great kid. A very quiet boy who did his work — and played hockey."

Bergeron, recalled Savoie, in Grade 10 failed to make the prestigious Seminaire Blizzard Midget AAA team, only to return the following year, his final at the high school, and be named the Blizzard captain. He then left home the following September to play Quebec League junior hockey in Bathurst, New Brunswick, and was selected No. 45 overall by the Bruins in that June's NHL draft (2003).

By October, he was an NHL regular at age 18 — some 36 months after being cut by the AAA team in 10th grade.

Like the little kid who sat inside the net for three months before one day just taking off, he was a quick learner, once in the game.

"Amazing, no?" said a beaming Savoie, proudly showing a visitor pictures of Bergeron that dot the walls outside the school's gymnasium. "Really amazing."

Following the Bruins' Stanley Cup victory in 2011, Bergeron surprised most everyone at the school by showing up unannounced with the Cup in hand for a private celebration with students and staff. It was separate from the public celebration he held in downtown Quebec City, where family, friends, and spectators celebrated

a favorite son's day with the Cup.

"It was a big, big rally — there must have been 1,000 or more at the rally in the city," recalled Kathleen Lavoie, longtime hockey reporter at Quebec City's La Soleil daily paper. "It was really something to see. We only learned about [the school] visit after it happened — he kept it a secret."

Mother is watching

Quebec City is by no means Bruins country. When the NHL Nordiques played here (1979-95), there was rabid support of the hometown Bleu et Blanc, and the young Bergeron brothers were among the Nordiques' ardent flag-wavers. Now, most of the local NHL fan base has shifted to the Montreal Canadiens.

"But I must say, that took a long time to happen," noted Lavoie. "With the Bruins winning the Stanley Cup, and doing it with Patrice Bergeron . . . in the last few years, we have more Bruins fans. Red Sox, too, more than Yankees or Blue Jays. We have something for Boston teams."

For all the years her son has played in Boston, noted Sylvie, she and her husband have missed no more than two or three of his games, either in person or on TV.

"I love to watch him play," she said. "His all-around game. He has an IQ for the game, an intelligence.

"I know him very well on the ice. He is a great player, Patrice. He knows always where to be. He does all the little things. It's a pleasure to see him play."

As a mother, she also knows how he suffered in the weeks and months after sustaining his brutal, season-ending concussion in October 2007, the one delivered by the Flyers' Randy Jones — the one that could have killed him. She was sitting in the stands at that end of the ice in Boston and remembers seeing Patrice's face go blank as his head slammed violently into the glass.

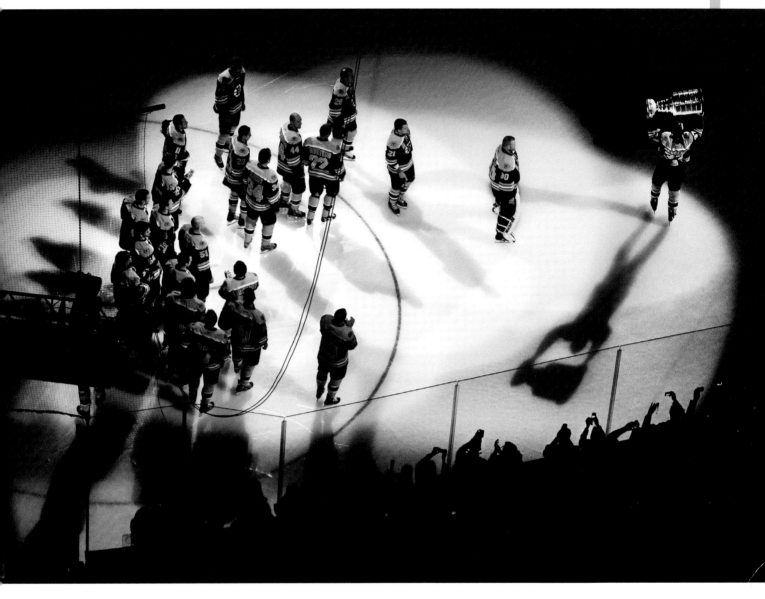

"Very hard to see, to watch . . . painful," she said. "It was a very, very rough time. I don't like to talk about it.

"And since that game, I don't see the game the same way — not just for Patrice, but for every player. I've had to learn to watch and not to worry. And that was hard for me.

"I am better now, but . . . but when it happened to him, I felt it in my body. And still when I watch now, I am — how you say? — I contract."

With both hands raised, she fashioned fists to exhibit her anxiety.

"As a mom," she said, "I am a bit more worried.

But like any experience, I've learned — it is the game he chose, the life he chose. Hockey. He loves that.

"And so, I have to accept his choice. I do. I am with him all the way, too. As the mom with your sons, you have to be with them in their choice and everything they do." ■

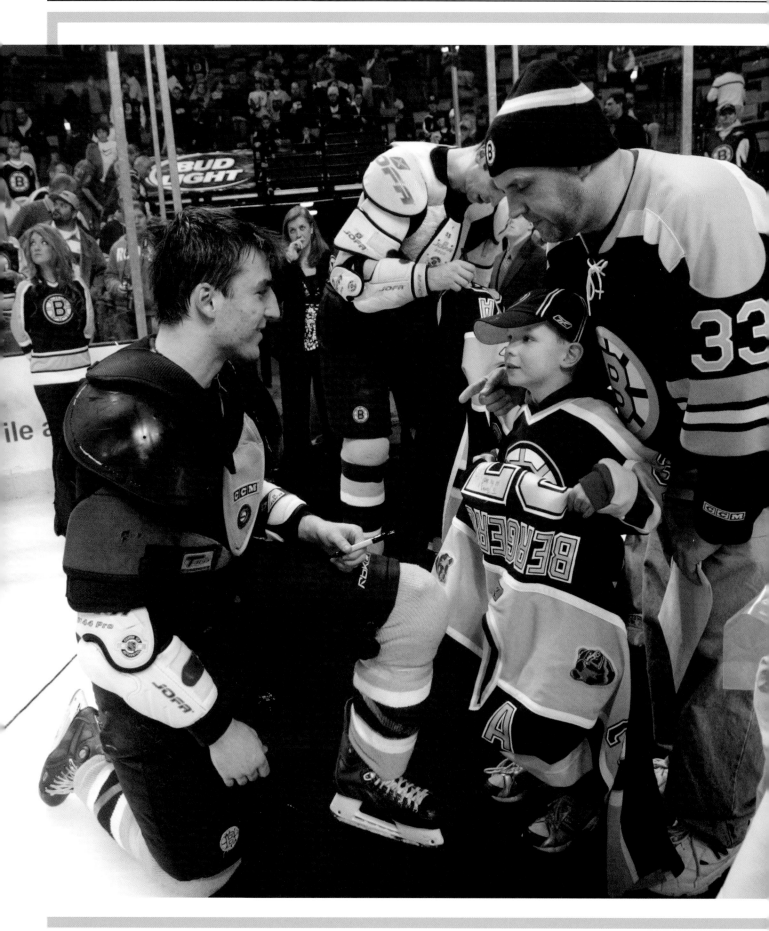

The special relationship between fans and Patrice Bergeron is just one of many ways he's been a natural fit with the Bruins.

PERFECT FIT

Through 999 Games, Patrice Bergeron and Bruins Have Been a Grand Pairing

By Kevin Paul Dupont | February 4, 2019

There was never a backup plan, the prudent something else, the alternative career path in case the hockey thing didn't play out exactly the way most every Canadian schoolboy dreams.

Patrice Bergeron was all of 10 years old when the mere suggestion of putting anything ahead of the game he loved struck a discordant note.

"I remember my piano teacher was telling me I should do less practices in hockey," Bergeron recalled last week after one more practice recital in his life's unending concerto on ice. "She was asking, you know, could I balance hockey and piano lessons?"

Nearly a quarter-century later, a look of utter disbelief creased the chiseled face of the four-time Selke Trophy winner (best defensive forward in the NHL). Less hockey, more piano?

"And I was like, 'Uhhh, OK, that's it,' " he recalled, raising a hand and wiping it through the air as if to erase such nonsense. " 'I'm done with piano.' "

With Bergeron, 33, about to play in his 1,000th NHL game, every one of them with that Boston spoked "B" on his chest, there can be no arguing that he was on the puck, read the play, and read it early. No surprise, not for a guy whose career trademark has been positioning, spatial awareness, deciphering in the moment exactly where he fits on the ice, absorbing the cacophony of all the other parts whirring around him. Being in the right place. Virtually every time.

On the verge of his 1,000th game with the Bruins, Patrice Bergeron was reflective about his amazing run.

When he steps on the ice to face the Islanders Tuesday night at the Garden, Bergeron will become only the fourth player to play career game No. 1 through 1,000 with Boston, preceded by Wayne Cashman, Ray Bourque, and Don Sweeney. In all likelihood, he'll join Cashman, a central character here in the Stanley Cup wins of 1970 and '72, as the only ones never to play for another NHL franchise.

"To me, the biggest thing, the most special thing about it, is probably the fact that all those games are with the Bruins organization," Bergeron said. "It just shows loyalty from my side, but also from the Bruins side, for me to be here for such a long period of time."

It is now season No. 15 for Bergeron, who arrived in town as a quiet, bright-eyed 18-year-old just weeks after the Bruins selected him 45th in the 2003 draft. Had Montreal's hockey minds been sharper, the Canadiens, with pick No. 10 (Andrei Kostitsyn) and 40 (Cory Urquhart), would have chosen the humble, unassuming kid from two hours away in Quebec City. How different things might be today for the bedraggled Les Glorieux, forever slouching toward their first Cup since 1993.

"Obviously, you dream of playing in the NHL," said Bergeron, who'll be the 323rd NHLer to reach the plateau. "You don't necessarily dream of playing 1,000 games, and you appreciate the meaning as you go along in your career, realizing who did it, and obviously the longevity is pretty special."

Bergeron is one of only two players on the Boston roster to have played here in the pre-Claude Julien era (along with Zdeno Chara). He has outlasted two general managers (Mike O'Connell, Peter Chiarelli) and played now for four coaches (Mike Sullivan, Dave Lewis, Julien, and Bruce Cassidy).

Bergeron recalled that Sullivan, now a two-time Cup winner as the Penguins bench boss, took him aside that rookie year and flatly told

him, "The sky's the limit for you." Prescient words from a coach who would not survive the regime change from O'Connell to Chiarelli in the summer of 2006.

"That always stuck in my head," Bergeron said. "Because it really gave me a lot confidence. It's kind of something that I tell myself sometimes when, you know, it's always work and believing in yourself to have the confidence to do the right things. Sometimes you'll hit a rough stretch, and it's just believing and pulling through."

Only 22 years old, and playing in career game No. 239, Bergeron nearly reached a premature limit to his promising career when he was hammered into the end boards by Flyers defenseman Randy Jones. Knocked cold, he collapsed to the ice, his 2007-08 season ended after 10 games by the severe concussion.

Months later, his father, Gerard, paced the parking lot outside the club's practice rink in Wilmington as Bergeron skated and trained in hopes of reclaiming his career, his life. Dad's voice choked with emotion, recalling that his son sat for weeks in his Boston apartment, blinds closed, eyes and brain unable to tolerate the daylight. The hit could have been lethal.

"I was only thinking about getting healthy," Bergeron said. "At that point, all I wanted to be was normal — like, on a general basis, not even as a hockey player. So it was hard for me to think about the future at that time because it was a tough year.

"But it never really crossed my mind that this could be the end, or whatnot."

Training staff and doctors remained positive. He fed off their energy and promise. He missed the remainder of the season but returned to work in October '08. Now, 760 games later, it remains a distant but poignant memory.

"The only thing it did for me was make me realize how much I missed it," Bergeron said. "And to be thankful — and I actually remind our young guys of that, be thankful in the dog days of

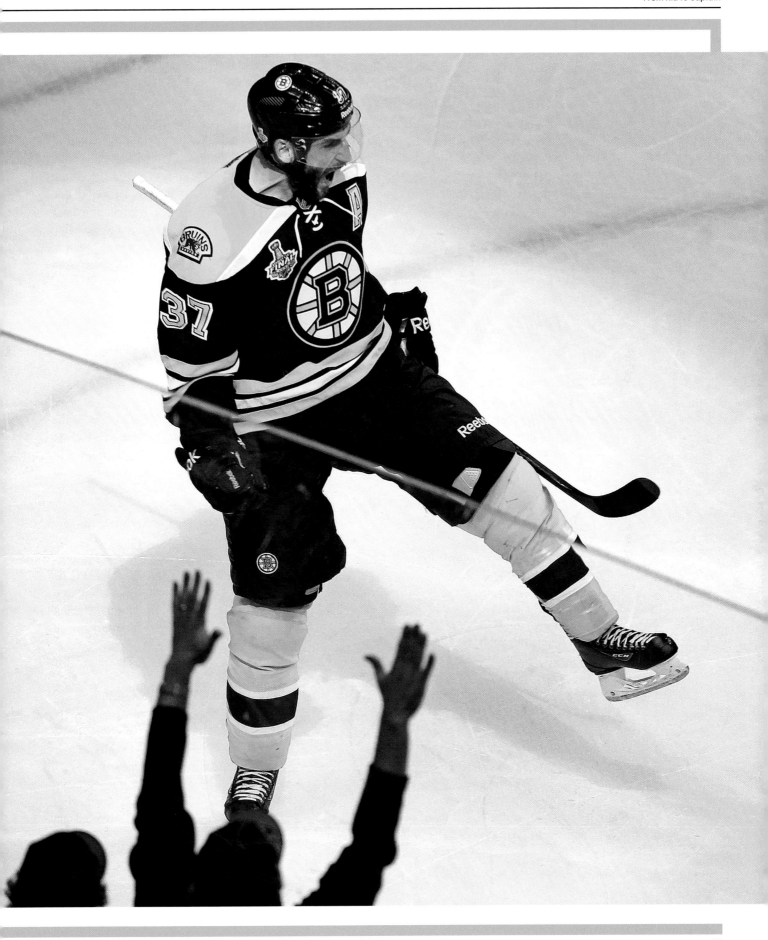

February, or when you feel it's dragging.

"It's a long season. It's a grind. You don't appreciate it as much. But you realize you miss it when you're away from it. You realize you have to be thankful and appreciate every day, and, yeah, enjoy it and have fun.

"It taught me to be more myself and not put so much pressure on myself."

Often lost in the Bergeron discussion, largely because of his identity as a consummate two-way defensive forward, is his ample offensive ability. Four Selke awards have hijacked the fact that he has serious offensive pop, particularly in recent years as the "bumper" on the No. 1 power-play unit.

Of all the players selected in the '03 draft, Bergeron ranks behind only Eric Staal and Ryan Getzlaf for total points (778) and he is steps ahead of noted gunners Thomas Vanek, Corey Perry, and Joe Pavelski, and others. Of the seven others in that draft to reach 1,000 games, he joins Dustin Brown (Los Angeles) and Brent Seabrook (Chicago) as the only players still with the clubs that drafted him. Vanek (367 career goals), originally a Sabres pick, is now with his eighth NHL team.

"It's loyalty on my side, because that's where I wanted to be," said Bergeron, who has three years remaining on an eight-year, $55 million contract signed in 2013. "I never really waited till the last minute to sign. It was almost always a year ahead. So the loyalty went both sides, obviously, so I appreciate it."

The official celebration will be Saturday, with Brown and the Kings at the Garden. Bergeron's mother, father, and brother (and family) will make the trip from Quebec City, along with his maternal grandparents. It will be grandma's first trip to Boston, a trip important enough for her to get her first passport. Bergeron's wife and three children (ages 2 months, 18 months, 3 years) will fill out the luxury box for the man of 1,000 games.

"Glad it's a matinee," said Bergeron, who lived with teammate Marty Lapointe's family when he moved to town more than 15 years ago. "It's a lot easier on the kids."

Bergeron plans to play for at least the three more seasons, the remaining term on his contract. He'll be 36 then and probably closing in on 1,300 games. His contracts here have totaled slightly more than $93 million. No telling how much longer he'll go beyond the spring of 2022.

"Take it year by year, I guess," he said. "But I don't think I'll be pulling a Chelios or a Z."

Chris Chelios was 48 when he suited up for his final NHL game with the Thrashers. Boston captain Zdeno Chara (1,456 games) will be 42 next month.

"Right now, I'm too far [from retiring] to put too much thought into it," Bergeron said. "Management seems fun, but it's also very time-consuming. Never say never, I like to say, but we'll see."

How odd. For anyone who has paid close attention to the first 999 games of his career, Bergeron has always seemed to know precisely the next step. Now with his career timeline shortening, the sky's limit reached, he's truly not sure where the play leads from here.

"Who knows?" said the maestro. "Maybe take some piano lessons. I don't remember any of it. I'd love to learn that again."

The bet here, 1,000-1, is that he nails it. ∎

While Patrice Bergeron wasn't known as being overly outspoken off the ice, he took a stand following the murder of George Floyd and committed $50,000 to social justice causes.

STEPPING UP

Patrice Bergeron Commits $50,000 to Social Justice Groups in Wake of George Floyd's Murder, Protests

By Matt Porter | June 3, 2020

Bruins star Patrice Bergeron is anything but an open book. He is often reticent to delve into the personal side of his life.

But the events of the last week, beginning with the death of 46-year-old George Floyd, a Black man, after a Minneapolis police officer knelt on his neck for nearly nine minutes, have led many NHLers to speak out on social media.

Bergeron, through the team's social media account, said he is joining them. He also committed $50,000 to social justice causes.

Bergeron's statement:

"As many of you know, I don't have social media. Right or wrong I've often tried to stay away from making my opinions public. As hockey players, we have a tendency to do our business while staying quiet, without wanting to make too much noise. It is in our culture.

"But surrounding the murder of George Floyd and the protests that followed, it made me realize that by not speaking up on the matter, and not using my voice as a professional athlete, it's in fact allowing racism to fester and continue. Silence is not an option for me anymore.

"I realize that I will never truly understand the fear, pain and suffering the Black community has endured. As a white man I have always tried to live by respect and equality, but I also acknowledge my privileges. I am disappointed in myself that it took this long for me to truly open my eyes. Seeing all this pain truly breaks my heart and forces me to seek answers.

"Today and going forward I want to listen, educate myself and stand up for the Black community. We cannot change the past, but we certainly can change the future. It is time to truly acknowledge this cry for help. It needs to be more than a simple Instagram post. Let's take real actions. With an open heart and compassion, I am determined to be an ally, continue to grow myself, and raise my children to be anti-racist.

"In addition to my words, my family and I are donating $25,000 to the Boston branch of the NAACP and $25,000 to Centre Multiethnique de Quebec.

"I will not be quiet anymore.

"With love, respect and the most sincere humility, Patrice Bergeron" ■

After a long wait, Patrice Bergeron was finally added to the prestigious list of Bruins captains in 2021.

'HE EMBODIES WHAT IT MEANS TO BE A BRUIN'

Patrice Bergeron Officially Named a Bruins Captain

By Trevor Hass | January 7, 2021

n a move that was expected following Zdeno Chara's departure, longtime center Patrice Bergeron was officially named captain of the Bruins on Thursday.

Bergeron, who is entering his 17th season in Boston, ranks third in team history in games and game-winning goals, and is fifth in goals and assists. Among active NHL players, he is third in plus/minus, ninth in playoff games, and 14th in points.

"For 16 seasons we have all watched Patrice grow not only into an elite player but also a tremendous leader," Bruins president Cam Neely said in a statement. "Patrice represents the Bruins organization and our fans with integrity, determination, and class.

"On and off the ice he embodies what it means to be a Bruin, and we couldn't be prouder that he will lead our team as Captain."

Bergeron, 35, is the 20th captain in team history — a role most recently held by Joe Thornton (2002-05) and Chara (2006-20). He won the Stanley Cup with Boston in 2011 and has spearheaded many charitable endeavors over the years.

"It's very humbling. It's a huge honor," Bergeron said. "There's been some tremendous captains and leaders along the way, and some legends of the game, and as I said it's an absolute honor and I'm going to try to keep bettering myself and learning and leading by example, but also trying to be me."

"Patrice Bergeron exudes leadership, character, talent, will, and empathy," Bruins general manager Don Sweeney said. "We all know Bergy embraces the legacy of the Boston Bruins, as he will with the captaincy.

"Bergy has earned the respect of all of his teammates, coaches, and everyone in the Bruins organization."

In making the announcement in the locker room, the Bruins had a little fun at Bergeron's expense. A video the team posted to social me-

dia shows Sweeney addressing the players and saying that the choice was obvious ... right before asking Brad Marchand to come up and accept his new jersey with a "C" on it.

"I'm really looking forward to taking this next step, but I think we all know who the real captain is," Marchand said before presenting Bergeron with his jersey No. 37 with the "C" stitched on the chest to the applause of his teammates.

The Bruins open the regular season next Thursday on the road against the New Jersey Devils.

Past Bruins captains

Zdeno Chara (2006-20)

Joe Thornton (2002-05)

Jason Allison (2000-01)

Ray Bourque (1985-2000)

Rick Middleton (1985-88)

Terry O'Reilly (1983-85)

Wayne Cashman (1977-83)

John Bucyk (1966-67 and 1973-77)

Leo Boivin (1963-66)

Don McKenney (1961-63)

Ferny Flaman (1955-61)

Ed Sandford (1954-55)

Milt Schmidt (1950-54)

John Crawford (1946-50)

Cooney Weiland (1938-39)

Dit Clapper (1932-38 and 1939-47)

George Owen (1931-32)

Lionel Hitchman (1927-31)

Sprague Cleghorn (1925-27)

OLD RELIABLE

Bergeron Handles Captaincy with Care

By Matt Porter | October 12, 2022

The hyperbolic, fan-created idea of Saint Patrice — beatified Bergy, the perfect hockey player and leader of the Perfection Line — makes the real Patrice Bergeron uncomfortable.

"I don't know if I love it," the social media-free Bruins captain said of the online chatter. "There's no such thing as being perfect."

By definition, the living cannot be canonized. But Bergeron has performed some righteous acts over the years, most recently last summer.

"He pretty much saved our season, you know?" said Brad Marchand.

Bergeron signing up for a 19th campaign in a Spoked-B sweater, at a remarkably team-friendly discount ($2.5 million in base salary,

$2.5 million in performance bonuses), restored order to the Bruins universe. Instead of scrambling to find a No. 1 center (good luck), they have the defending Selke Trophy winner, who scored 65 points in 73 games last season.

Bergeron's comeback helped convince fellow pivot David Krejci, who had no plans after playing last season in Czechia, to return to the NHL for at least one more run.

Had Bergeron, 37, decided that 18 Hall of Fame-caliber seasons were enough, the on-ice loss would have been staggering.

It made Marchand shudder: "He's the best two-way player to ever play the game."

Those on the Bruins bench, said Brandon Carlo, shout out "Selke" when Bergeron makes

a great defensive play (Bergeron does indeed hear them). How would Carlo feel without those moments? "I'm not going to allow myself to think about it."

Bergeron takes every important faceoff, helps kill every penalty, anchors the middle of the power play, faces opponents' top centers nightly, and dishes the puck to his wingers, some 1,216 regular-season and 167 playoff games into his career.

Said Chris Wagner, "He's a robot as far as I'm concerned."

Bergeron, however, lifts the Bruins in ways greater than his goals, assists, and shutdown defense.

. . .

He knows he is nearly done. This year might be his last; he maintains he is focused solely on 2022-23. Borrowing a line from the famed All Blacks New Zealand rugby team, Bergeron said he is determined to "leave the jersey in a better place" than he found it. Others have shown him how.

In 2003, Martin Lapointe helped an 18-year-old who was nervous to speak English adjust to life in the pros. Mark Recchi, a Bruin from 2009-11, coaxed him out of his shell. For 14 seasons, Zdeno Chara was the iron that sharpened his iron.

In 2009, Bergeron was leading by example rather than expressiveness when his Hall of Fame linemate challenged him. "Guys listen to you," Recchi told a 23-year-old Bergeron, who was taken aback.

"That meant a lot, coming from Rex," said Bergeron.

Recchi's advice: "Any time you need to say something, just speak from the heart," Bergeron recalled. "Sometimes people get lost in the fact they need to say something. If you use your heart instead of your brain, the right words come out."

Since accepting the captaincy from Chara three seasons ago, Bergeron has made Marchand, Carlo, Charlie McAvoy, David Pastrnak, and others understand that caring ethos. Stories like that of Bruins short-timer Gemel Smith, who was struggling with depression in 2019 when Bergeron advised him to seek counseling, are more common than the tight-knit Bruins let on.

"Every day, he can understand just by looking at everybody how each guy is doing mentally, because he pays such close attention," Marchand said. "He'll come up and be like, 'Hey, I think so-and-so might be having a tough time, let's go talk to him.' Or 'I'm going to pull him aside.' Just little things like that.

"When you're younger, you walk into the rink and do what you need to do for the day. But his first goal is, how is every guy in the room doing?"

Once Bergeron learned to channel his natural empathy, a leader was made.

"I think I've always been a guy who is close to other people's emotions and feelings," Bergeron said. "At times it affects me; I know something's going on, so I want to reach out. There's good and bad to it. If I feel something, I kind of have to reach out somehow.

"The connection is what's most important on the team, right? That's how you're going to compete in battle, if you actually care for one another. That doesn't mean it's always rainbows and sunshine, but it's being able to talk to each other whether it's by being positive or whether it's making sure we're accountable."

Bergeron and his wife, Stephanie, live in Newton with their three children under the age of 7. He flips his hockey switch to "off" once he arrives home, but the lights typically keep blinking. He has learned to delegate.

"There's always things that come up," he said. "You're a bridge with the organization, the coaches and management, you're a bridge obviously with the players. You have to have good communication with everyone. Our leadership

group makes it easy. They help me carry the burden, if that's the right word.

"Make the decision you think is best for the team. I trust you guys to do that. It doesn't always have to be me."

. . .

Bergeron was speaking by phone as he drove to the airport. The first charter flight of the season awaited.

The daily grind. For his team, in the city he loves, with those he cares about. It makes him forget nearly two decades' worth of NHL wear and tear.

"I'm excited for the year," he said. "I think we have a great mix of older players and guys with experience but also some younger guys who are going to push. Healthy competition is always important. Adversity early in the year, with the guys missing, I see that as a positive. We can see what we're made of. We can learn from that.

"Every year is a clean slate. You write your own story. Every team is in the same situation. It's easy to say I want to win, but how do you do it? What is the process? To me, that's the exciting part."

When a 20-year-old Krejci debuted in January 2007, a 21-year-old Bergeron was wearing an "A" on his sweater.

"The way he carried himself, the way he cared for other players, he made me feel comfortable," Krejci said. "Guys looked up to him. I looked up to him. I always wanted to be as good as him.

"We have a good, healthy competition between us, which helped us through so many years. We'll keep that going this year."

Does he still look up to him?

"Yeah," Krejci said. "Who doesn't?" ■

'I'M GLAD WE WERE HEARD'

Patrice Bergeron Says Bruins Stood Together on Mitchell Miller

By Matt Porter | November 7, 2022

While a hand-by-hand vote was not taken, and not every player had something to say, Bruins captain Patrice Bergeron said the locker room stood together over the weekend against the team's brief association with Mitchell Miller.

"I'm glad we were heard," Bergeron said Monday.

Bergeron wouldn't specify what team president Cam Neely and general manager Don Sweeney said when they addressed the team in Toronto Saturday, but referred to it as "an open conversation."

He said he understands the reaction of Bruins fans, who were overwhelmingly negative about the addition of Miller, the 20-year-old defenseman who signed Friday and was headed for an exit by Sunday.

"I think that situation goes back to what we've built here as an organization, as a team, as a locker room is to be inclusive and a locker room of respect and integrity," Bergeron said.

"For us, nothing has changed as far as who we are as individuals, as [people], as a culture in this locker room, what our core values are. We hear you. Also, we feel like our values remain the same."

Brad Marchand reiterated those comments, saying that management "made a mistake" and that players appreciate the fan support.

"Any time there's this much media attention, it definitely weighs on your mind a little bit," he said. "There's all kinds of situations that come up throughout a year. That's part of what's great about hockey — once you get on the ice, you don't worry about it."

The club was looking for a reset after a loss in Toronto and all the negativity surrounding the team.

"It was an important topic to talk about, I guess let your voice be heard and have those discussions," Bergeron said. "That being said, of course you want to refocus and shift the focus back to what we can control, and play the best hockey we can play."

Bruins coach Jim Montgomery was not consulted about the Miller signing, and said his confidence in his general manager and team president remains high. He said the players should easily put the situation behind them.

"Because of the culture we have here," he said. "We listen to each other. I think you saw a lot of people listening to each other and sharing their beliefs. There's a lot of respect within the Boston Bruins organization, from the top of the food chain all the way to the bottom. I don't see it being an issue." ∎

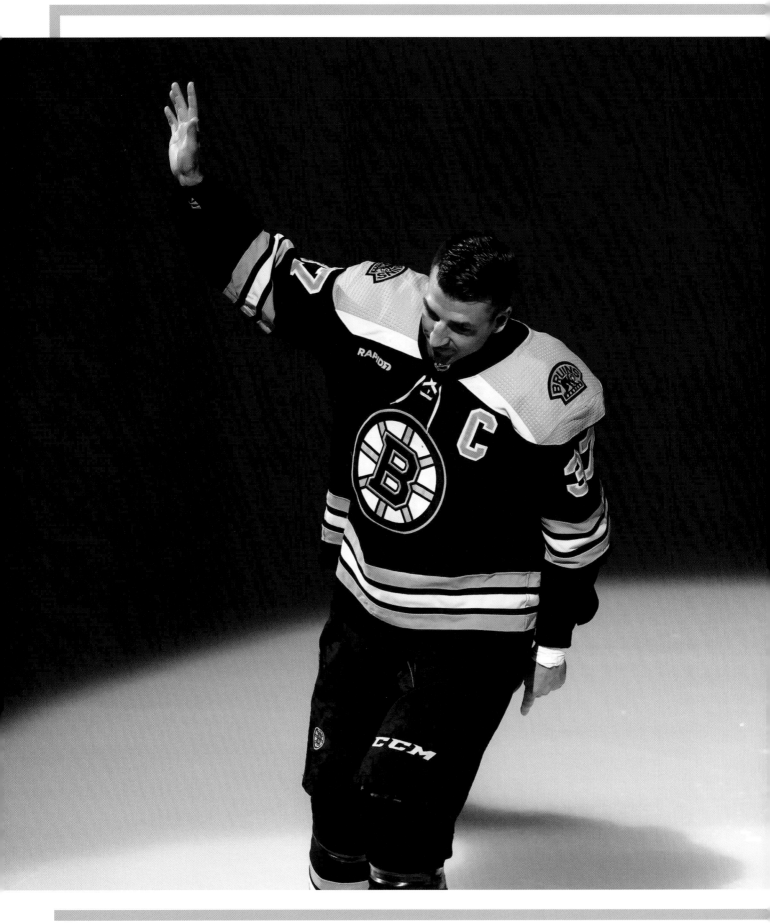

A MILESTONE FOR BERGY

Patrice Bergeron Saluted for Reaching 1,000 Points

By Matt Porter | December 17, 2022

Patrice Bergeron has no career plans beyond this season. Coach Jim Montgomery hopes the captain doesn't want his job.

Montgomery didn't think he was getting through with his intermission comments in Saturday's 4-2 win over Columbus. So with 40 seconds left in the second, he told Bergeron: It's your locker room.

"I just hope he doesn't want to be a head coach, because we came out and played our best period of the game," Montgomery said. "That speaks volumes, one how much I trust him, and how much the players listen to him."

After Bergeron's message — take care of details, be accountable to each other, and empty the tank — the Bruins earned a win for their captain

on a day he was celebrated for scoring his 1,000th point on Nov. 21 in Tampa.

"It was special. It means a lot," said Bergeron, whose three children, Zack, Victoria, and Noah, were plodding around the dressing room afterward. They wrote "Congratulations Dad" on the team's touchscreen video board.

"I've been around for a long time in this city, playing in front of these fans, and I'm very appreciative of all the support I've had over the years from them," Bergeron said. "It was a nice moment. Happy to share that with my family and my teammates as well."

The 10-minute ceremony before the game saw the TD Garden crowd drown out public address announcer Jake Zimmer as he started to

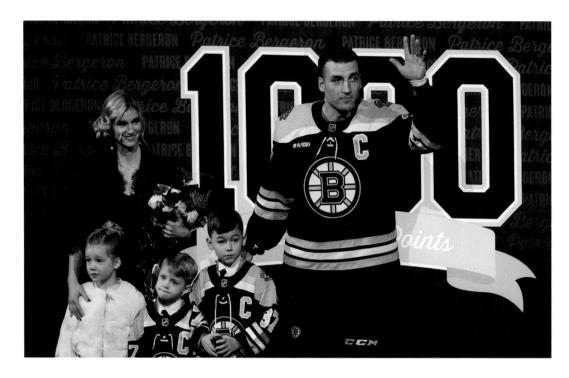

Right: Patrice Bergeron is joined by his family to celebrate yet another milestone in his legendary career. Opposite: Patrice Bergeron's teammates swarm him after he tallied his 1,000th career point on November 21, 2022, against the Lightning.

speak. The crowd chanted "Bergy."

Bergeron skated across the ice, carrying a bouquet of flowers for his wife, Stephanie. Their children stood by.

The Bruins asked longtime Canadiens PA man Michel Lacroix to add comments in French. Bergeron recognized the voice.

"That was a cool touch," he said. "That was very classy."

A video full of scoring plays ran on the jumbotron. Bergeron's first goal, Oct. 18, 2003, against the Kings in Los Angeles. His end-to-end goal in 2006 against Montreal. His first overtime winner, in 2006 against the Ducks. His assist on Marco Sturm's Winter Classic winner in 2010.

His 100th goal, in 2010 against Toronto. A shorthanded strike for his 200th. His first hat trick, in 2011 against Ottawa. And so on.

Fans watched the backcheck before his goal in the 2019 Winter Classic. And then, some four weeks ago in Tampa: Brad Marchand excitedly pointing at his pal, who recorded point No. 1,000 on a secondary assist.

Standing in front of a giant banner bearing his image and "1,000," Bergeron accepted gifts. Johnny Bucyk, 87, presented him with a Tiffany crystal on behalf of the NHL. General manager Don Sweeney handed Bergeron a golden stick, hockey's traditional 1,000-point trophy. Bergeron got his silver stick (1,000 games) in Feb. 2019, before he scored the winner against the Kings.

Team president Cam Neely presented him with a check for $37,000, which he will donate to a charity of his choice. Bergeron, surprised by the gesture, said he didn't know where the money would go.

Alternate captains Marchand and David Krejci bestowed their longtime teammate with gifts on behalf of the players.

The ceremony concluded with a video tribute including the other three members of the Bruins' 1,000-point club: Bucyk, Ray Bourque, and Phil Esposito.

Said Espo: "If there's a better all-around player in the league, I want to know who it is. I watched this guy for years. Love the way he plays. He's so responsible and he just plays his game. For me, he's a first-[ballot] election to the Hall of Fame."

As Bergeron returned to the bench, his teammates rapping their sticks, he touched his hand to his heart and waved several times to the crowd. The crowd chanted "Bergy." ∎

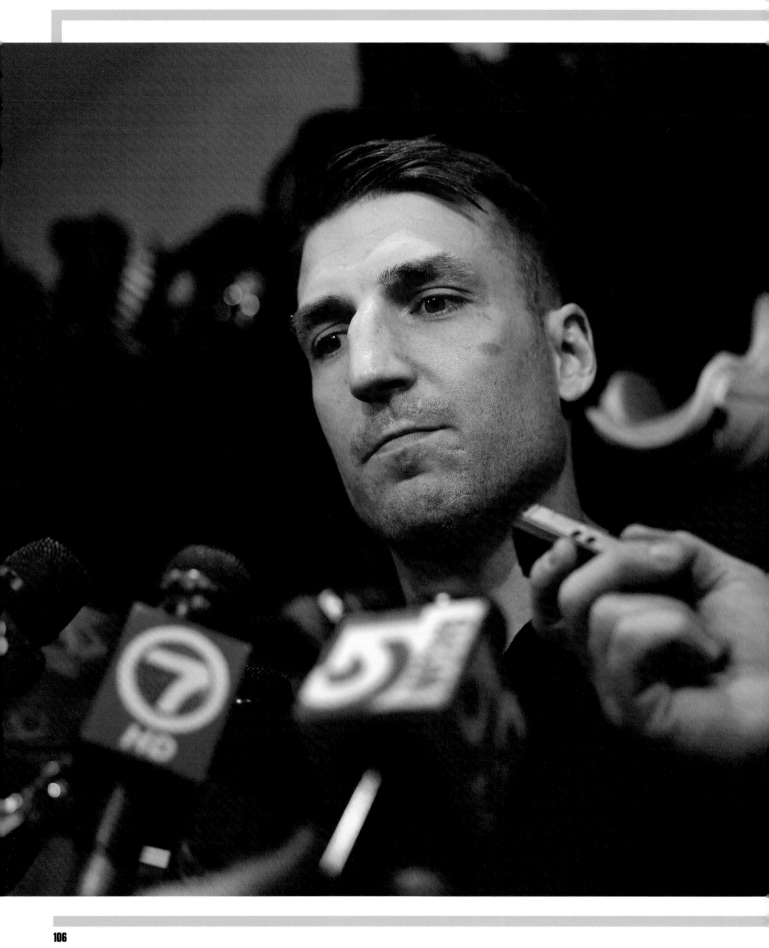

EASTERN CONFERENCE FIRST ROUND, GAME 7

❖ PANTHERS 4, BRUINS 3 (OT)

April 30, 2023 • Boston, Massachusetts

Patrice Bergeron speaks to media in the days following the devastating first-round Game 7 loss to the Panthers.

HEARTBREAKER

Game 7 Loss Hard to Take with Uncertain Future for Bergeron

By Tara Sullivan

Game over, season over, and maybe … sigh … a storied Bruins career over, too.

There was Patrice Bergeron, skating alone toward the far end of TD Garden ice Sunday night, as far from the Florida Panthers celebration in the opposite corner as he could get, the man on the wrong end of a 4-3, overtime, Game 7 loss now a solitary figure making slow, deliberate circles on his own. Nowhere else to go, nothing else to do but wait for the obligatory handshake line with the winners, wait for the emotional procession of hugs with his teammates, wait for the inevitable questions of not simply what went so wrong for a Bruins team expected to win the Stanley Cup, but whether he'd just played his final game in black and gold.

"Really difficult," he would describe it afterwards. "Obviously, it's not the outcome you want and extremely disappointing, especially with the team that we had. It's not where we want to be.

"I mean, it hurts, you know. It's what it is. You compete hard and you battle all year for that, so it's hard."

Hard for him, hard for his teammates — Did you see that final embrace with Brad Marchand, heads resting on each other's shoulders until finally letting go for Bergeron so he could wave one final stick in farewell? — and hard for fans so

After a historic season for the Bruins, an early playoff exit wasn't how Patrice Bergeron envisioned ending his storied career.

spoiled by the class, grace, talent, and skill of the captain they call Bergy.

Is this really the way it's all going to end?

"Yeah, gotta take some time and talk with the family and go from there," he said. "It's too — right now it's hard to process anything, right? Obviously, we're shocked and disappointed. That's it."

If that is truly it, Bergeron will go down as one of the greatest athletes in Boston history.

Think about it — when you close your hockey eyes and imagine the Bruins across the last two decades, what do you see?

Is it No. 37? It has to be, doesn't it?

The smooth black-and-gold jersey, crouching for a faceoff or flying in the wake of a sprint to the goal, always there, leading the way for all things Bruins, a perfect "C" shining through the stitches atop the left chest.

Bergeron has been everything to the Bruins and the Bruins have been everything to Bergeron since he joined the varsity as a fresh-faced 18-year-old rookie. A second-round pick with a first-class heart, Bergeron would evolve not only as one of the best players of his generation, but one of the best leaders, too. A conversation with any of his current teammates quickly reveals an impact on the franchise destined to last far longer than his playing days will, underscored most recently when linemate and close friend Marchand talked of details yet to come about all Bergeron has done to construct a Bruins culture.

But those comments were made back in Florida before Game 4 of this maddening series against the Panthers, back when the Bruins seemed so in control of their postseason lives, poised to sweep their first two road games of the series and return home with a chance to close it out on the same night they would welcome their ailing captain back into the fold. The re-

cord shows how wrong it has all gone from there, how Bergeron's return (he said Sunday he'd been healing from a herniated disk), though strong, was not enough to push the Bruins to victory in Game 5 at TD Garden, how it all fell apart in the ugliest all-around effort so far in the Game 6 Florida nightmare, and now, a heart-wrenching 4-3 loss in overtime in Game 7.

At 37, with more than enough wear and tear on his body to justify any decision he makes about his future, whoever doesn't expect a retirement announcement is operating more in the theater of hope than reality.

First-year coach Jim Montgomery is holding out hope.

"Learned a lot from him," Montgomery said. "Hope to learn even more from him next year."

Bergeron wouldn't have been blamed had he made that decision a year ago, when he seriously contemplated retiring but chose instead to come back for one more shot at the Cup. Across a record-setting regular season and another Selke-worthy performance of his own, it was always about the playoffs, about writing a championship ending worthy of a future Hall of Fame career.

So yes, the Bruins knew they had oh-so-much to lose Sunday night at the Garden, knew they risked adding their names to the embarrassing list of Presidents' Trophy winners turned postseason losers, knew they should never have allowed themselves to be pushed so far back against the hockey wall.

But mostly, they knew they could lose Bergeron, knew they could also bid farewell to fellow 37-year-old veteran David Krejci, knew they could send them on to a heartbreaking heap of what might have been.

Could this really have been their final game in black and gold?

"You can look everywhere for motivation,

but that's a big one," Taylor Hall admitted before the game. "It's a special group and this is obviously the biggest thing that we've faced. If we get through this, the sky's the limit."

"Getting through this" is not what the Bruins envisioned when Krejci came out of a one-year European hiatus to return to the Bruins, not what they scripted when Bergeron hopped onto Montgomery's positivity train and drove it toward a historic 65-win season, not where they expected to find themselves after cruising to the 3-1 series lead.

But here they are, nowhere else to go, nothing else to do. And here the captain was, alone, taking one more turn on the ice.

"Just thanks for the support all year," he said. "It's a special city, it's a special fan base and an organization. So it's more just saying thank you for the support all year."

Hey Patrice: Right back at you. ∎

After 19 unforgettable seasons, Patrice Bergeron announced his retirement from the Boston Bruins and NHL.

'I HAVE ONLY GRATITUDE THAT I LIVED MY DREAM'

Patrice Bergeron Announces Retirement

ByKatie McInerney | July 25, 2023

Patrice Bergeron announced his retirement Tuesday after 19 seasons in the NHL.

The Bruins captain leaves Boston as third among all Bruins in games played (1,294), goals (427), and points (1,040); and fourth in assists (613).

Patrice Bergeron's retirement statement

"When I was around 12 years old a teacher asked everyone in my class to write about our dreams. For me, my dream was already clear: to become a professional hockey player.

I was probably a little naive growing up, because in my mind this dream was never a question of if, but when it would happen. The path to making my dreams come true was not easy. I faced adversity and made so many sacrifices, but throughout it all my love for the game only grew and my determination to achieve my goals always remained strong.

For the last 20 years I have been able to live my dream every day. I have had the honor of playing in front of the best fans in the world wearing the Bruins uniform and representing my country at the highest levels of international play. I have given the game everything that I have physically and emotionally, and the game has given me back more than I could have ever imagined.

It is with a full heart and a lot of gratitude that today I am announcing my retirement as a professional hockey player.

As hard as it is to write, I also write it knowing how blessed and lucky I feel to have had the career that I have had, and that I have the opportunity to leave the game I love on my terms. It wasn't a decision that I came to lightly. But after listening to my body, and talking with my family, I know in my heart that this is the right time to step away from playing the game I love.

I also know that none of this was possible on my own, and I would like to humbly take this opportunity to acknowledge some people who helped me achieve my goals and who made my career so special.

From my minor hockey days in Quebec City all the way through major junior in Acadie-Bathurst, there were so many coaches, teammates and parents who helped me fall in love with hockey. Thank you for laying the groundwork on what became a lifelong passion.

In 2003, the Bruins drafted me, and from the moment I put my draft sweater on, everyone in the organization believed in me. I want to thank the Jacobs family, team management, coaches, trainers, support staff, team doctors and psychologists, scouts and TD Garden staff. The commitment of this group of people and constant support on and off the ice made wearing the Black and Gold so special every day.

One of the best parts of pulling on the spoked-B jersey is the incredible history of the franchise. The players that came before me always welcomed me with open arms and were always there with encouragement, to listen and help me better understand the tradition and responsibilities that come with playing for the Bruins.

While not always easy, I always tried my best to understand that part of being a professional hockey player included my responsibility to the media who helped tell our story to the fans. I enjoyed getting to know some of you personally over the years and I always appreciated being covered fairly and the job that the media did telling the story of our team.

Over the last 20 years I have had the honor of taking the ice with so many great teammates. I have tried to learn something from each and every one of you and I always tried to be the best teammate that I could be. I will never forget your trust, the laughs, the endless memories, the ups and downs, and ultimately the long lasting friendships. I will forever be grateful being a part of such an exceptional group of men, and I will carry the pride of winning in 2011 with me forever.

The amazing people of New England welcomed a young French Canadian who didn't speak great English and you treated me like one of your own. I can't imagine representing a better community or more passionate fan base than the Boston Bruins. Your passion, your dedication and your kindness towards me and my family will never be forgotten. Please know that every time I took the ice I tried to compete for you the right way, and off the ice I tried the best that I could to give back to the community that supported me. The connections and friends that my family and I have made here are unquantifiable. Boston is, and will forever be, a special place for me and my family.

There is only one other jersey that I ever wanted to wear, and that is the Canadian jersey. Representing my country at the highest level - especially winning Gold in Vancouver and Sochi are also some of my proudest moments. I would like to thank everyone who helped make those experiences possible.

Navigating life as a professional athlete is not easy, and my two agents, Kent Hughes and Phil Lecavalier, helped me find my way. Your guidance through the ups and downs of my career helped eliminate distractions and uncertainty so that I could focus on being the best

Patrice Bergeron's retirement statement expressed gratitude for the many that helped make his experience exceptional in Boston, chief among those the many great teammates he played with over the years.

player that I could be. I have also had a great team of professionals in Boston and Quebec who have been instrumental in both my physical and mental health, allowing me to reach my maximum potential.

Since day one, my friends and extended family in Quebec have been by my side. You guys know who you are. I remain so appreciative of your continued support.

To my mom, Sylvie and my dad, Gerard. It all started with you both, and your unwavering love. I couldn't have asked for better parents. What I have achieved, and who I have become, is because of you. The sacrifices that you both made for my goals are appreciated more than I can ever state. You guys have always believed in me and my dreams, even when no one else did. You always found the right way to help guide me in this journey with endless support.

To my brother Guillaume. It's hard to find words to explain our bond. You have been the biggest influence in my life and the best role model a little brother could hope for. My dream started by playing street hockey with you as young boys and you have been my number one fan every step of the way. I am forever thankful for all of your advice, words of encouragement and for always having time to simply listen to me.

To my wife Stephanie. Steph you're my rock. You put your career aside and allowed me to pursue my passion. Grateful is an understatement for my appreciation for your sacrifices. You always see the positive in every situation and your unconditional love means the world to me. Most importantly, you always see me as a husband and a dad before a hockey player. The kids and I are so lucky to have you. I love you.

To my wonderful kids Zack, Victoria, Noah and Felix. Daddy loves you so much. As I turn the page on this chapter of my life I am hopeful that through my experiences you realize that anything in your life is possible. Believe in your

dreams and follow the voice inside you. Work endlessly for whatever it is that makes your eyes sparkle, and when times are tough, get back up and keep pushing. I'm the prime example that anything is possible and that amazing things happen when you believe in yourself and do what you love. Daddy will always be in your corner no matter where life takes you.

Finally, to the next generation of hockey players. I had a dream at 12 years old, and through hard work and perseverance my dreams came true more than I ever could have imagined. Respect the game and your peers. Welcome adversity and simply enjoy yourself. No matter where you go from there the game will bring you so much happiness.

As I step away today, I have no regrets. I have only gratitude that I lived my dream, and excitement for what is next for my family and I. I left everything out there and I'm humbled and honored it was representing this incredible city and for the Boston Bruins fans." ■

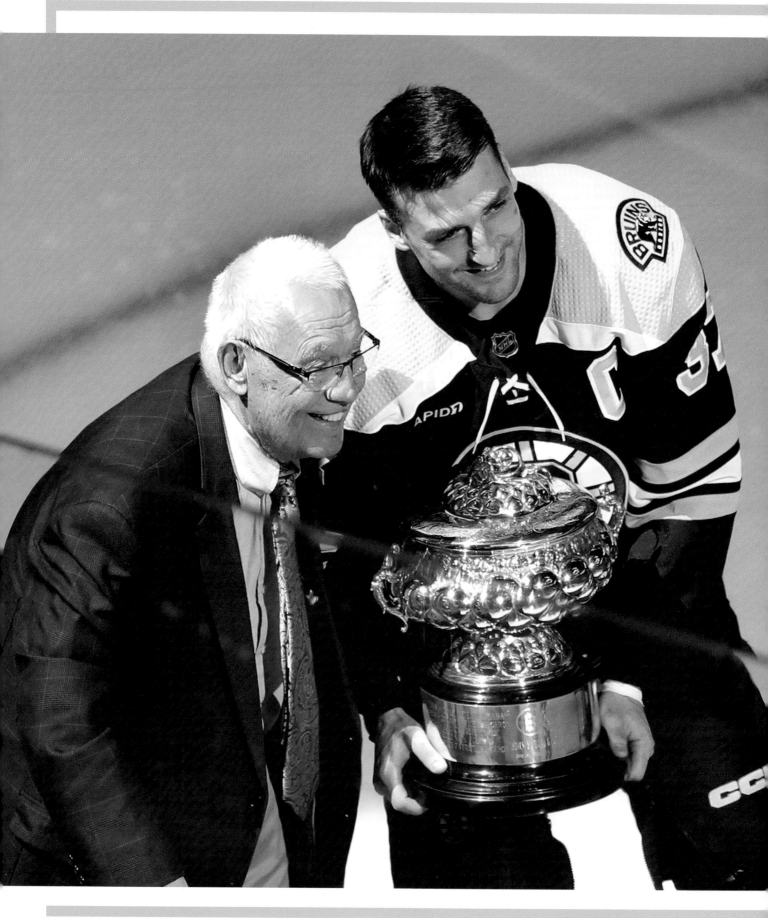

A FOND FAREWELL

After a Brilliant 19-Year Career, Bruins Captain Bergeron Retires

By Jim McBride | July 25, 2023

Next stop: The rafters.

Patrice Bergeron announced Tuesday morning that he is retiring after a remarkable 19-year career with the Bruins.

His No. 37 will soon hang above the Garden ice alongside other Boston greats Eddie Shore (No. 2), Lionel Hitchman (3), Bobby Orr (4), Aubrey "Dit" Clapper (5), Phil Esposito (7), Cam Neely (8), Johnny Bucyk (9), Milt Schmidt (15), Rick Middleton (16), Willie O'Ree (22), Terry O'Reilly (24), and Ray Bourque (77).

The preeminent two-way center of his generation, Bergeron, who turned 38 Monday, spent the last three seasons as Bruins captain, though his leadership was evident the day he arrived on Causeway Street as a second-round draft pick in 2003.

"For the last 20 years I have been able to live my dream every day," Bergeron wrote on the club's social media accounts. "I have had the honor of playing in front of the best fans in the world wearing the Bruins uniform and representing my country at the highest levels of international play. I have given the game everything that I have physically and emotionally, and the game has given me back more than I could have ever imagined.

"It is with a full heart and a lot of gratitude that today I am announcing my retirement as a professional hockey player."

Bergeron helped guide the Bruins to the Stanley Cup in 2011 and won a pair of Olympic

gold medals with Team Canada. He ends his career still playing at an extraordinarily high level. Last month he won his record-extending sixth Selke Trophy as the league's best defensive forward. He was nominated for the honor 12 times, prompting many to suggest the NHL should consider changing the name of the award.

In his 19th season, Bergeron put up 27 goals and 31 assists for 58 points in 78 games. He missed four games in the playoffs because of a herniated disk in his back, scoring one goal in three games as the Bruins were eliminated by the Panthers in the first round.

Teaming with longtime captain Zdeno Chara, Bergeron helped lead the Black and Gold out of the post- Bourque and Joe Thornton malaise. Though statistics are not a proper measure of his impact on the franchise, Bergeron sits third among all Bruins in games played (1,294), goals (427), and points (1,040), and fourth in assists (613). The only names ahead of him on those lists: Bourque and Bucyk (games played); Bucyk and Esposito (goals); Bourque, Bucyk, and Orr (assists); and Bourque and Bucyk (points).

In the playoffs, Bergeron ranks second in games (170), and third in goals (50), assists (78), and points (128). He scored 10 playoff game-winners (third in Bruins history, one behind Neely and Brad Marchand).

Bergeron scored two goals — including a memorable shorthander — in the Game 7 win over the Canucks that secured the Cup in 2011.

His Game 7 overtime strike in the 2013 first round against Toronto, which followed his extra-attacker tying goal with 51 seconds left in regulation, was an all-time Bruins playoff moment, and prompted one of the greatest radio calls in Boston sports history — Dave Goucher's "Bergeron! Bergeron!"

Bergeron will have to wait at least three years, but there's no doubt he will take his place among the game's greats at the Hockey Hall of Fame in Toronto. It would be a surprise if he isn't a unanimous first-ballot choice.

His Stanley Cup (2011) and his membership in the exclusive Triple Gold club — gold medals for Canada in the Olympics (2010, 2014), World Championships (2006), and World Junior Championship (2005) — make him one of the strongest Hall of Fame candidates in years. His class and grace on and off the ice make it a no-brainer.

Like David Krejci, his longtime teammate and fellow center, Bergeron played 2022-23 on a remarkably team-friendly deal. He earned $2.5 million in salary, with another $2.5 million in performance bonuses. The latter, combined with Krejci's achievement-based earnings ($2 million in bonuses beyond his $1 million salary), had the Bruins moving a league-high $4.5 million in salary-cap overages to their 2023-24 books.

Both general manager Don Sweeney and team president Neely indicated last month that money would not be an obstacle if Bergeron decided to return for a 20th campaign.

While many of Bergeron's contemporaries have signed more lucrative contracts, he played his career mostly on modest deals. He never counted more than $6.875 million annually against the salary cap, or earned more than $8.75 million in actual salary, according to CapFriendly. That website estimated he earned north of $96 million in playing salary.

After his career nearly ended at age 22, on a hit from behind by Flyers defenseman Randy Jones in 2007, Bergeron became a fierce advocate in the fight against concussions and a proponent for mental health. He played through many below-the-shoulder injuries, including a car-crash list (cracked rib, torn cartilage, punctured lung, separated shoulder) in the 2013 Stanley Cup Final.

Succeeding Chara as captain in 2021, Bergeron led the Bruins with an empathetic

bent, a focus on family (he and his wife, Stephanie, have four young children), and a devotion to the club's process. Marchand, his linemate since 2010 and the obvious choice to succeed him wearing the "C," was taking mental notes.

Bergeron is the rare professional athlete who is not replaceable.

"I didn't know that he was that good," Bruins coach Jim Montgomery said at last month's NHL Awards. "He's incredible. He's the best defensive player I've ever had the fortune to watch or see. And he does it daily.

"And then, his ability to impact others and make them better people is the other thing that I didn't know. I'd heard he was a great leader. Everybody talks so highly of him, but when you're around it daily, it's special and you learn from it. And I think I'm a better person because of that."

Former Bruins coach Bruce Cassidy said yesterday, in a statement released by the Golden Knights: "I'd like to offer my congratulations to Patrice on a legendary career. It was a privilege and an honor to work with such a first-class player and person. Thank you for all you have done and I wish you, Steph, and your children all the best." ∎

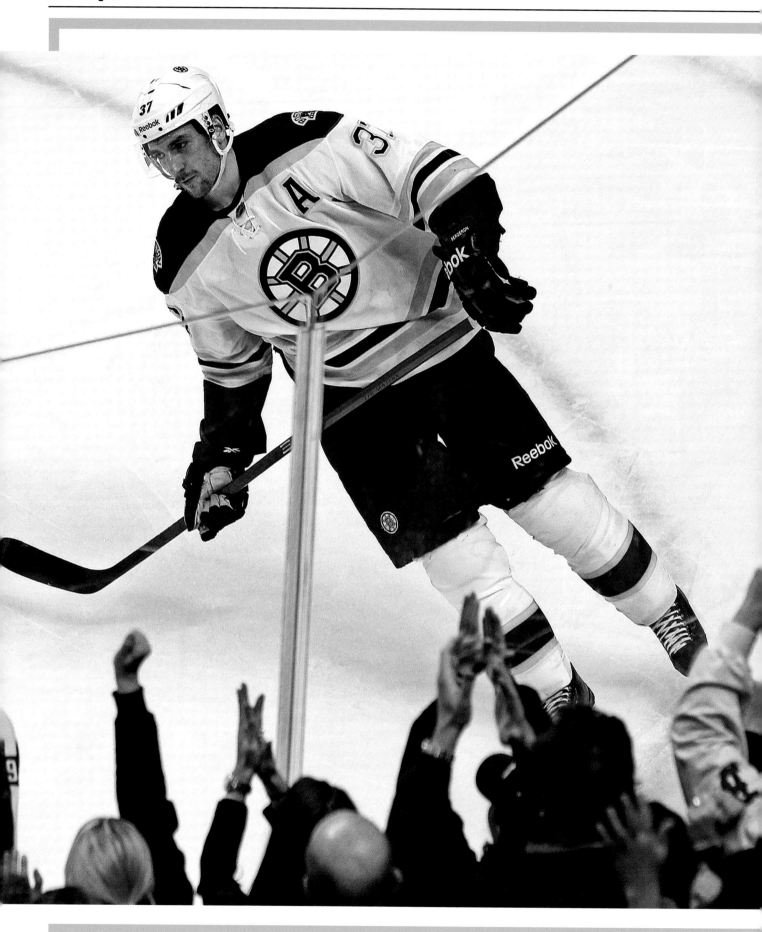

Patrice Bergeron finished his illustrious career in the top four for the franchise in several categories, including third in games played (1,294), goals (427), and points (1,040), and fourth in assists (613).

BRUIN FOR LIFE

A Look Back at Patrice Bergeron's Memorable 19-Year Career with the Bruins

By Andrew Mahoney | July 25, 2023

After the Bruins' record-breaking 2022-23 season came to an abrupt end with a first-round exit against the Florida Panthers, captain Patrice Bergeron told reporters that he would take some time to decide whether he would return.

With the offseason in full swing, Bergeron announced Tuesday that he has decided to call it a career, 20 years after the Bruins selected him in the second round of the 2003 NHL Draft with the 45th pick.

He finishes his career in the top four for the franchise in several categories, including third in games played (1,294), goals (427), and points (1,040) and fourth in assists (613).

Here is a look at some of the memorable moments from Bergeron's time with the Black and Gold.

Oct. 15, 2003: Playing in his fourth game, Bergeron records his first NHL point when he assists on Brian Rolston's goal at Dallas. He would record his first goal three days later in Los Angeles

April 2006
In just his second season, Bergeron scores 31 goals in 81 games. Highlights include his first overtime winner on Jan. 16 against Anaheim and a 3-point night on March 21 in which reached 100 career points. He was named an alternate captain ahead of the following season.

Oct. 27, 2007: In just the 10th game of the season, Bergeron is hit from behind by Philadelphia's Randy Jones and crashes into the boards face-first. He suffers a broken nose and a concussion, and is knocked unconscious. Team medical personnel rush onto the ice, cut away his gloves and uniform, tape his legs together and tape his arms across his chest before he is stretchered off. He would miss the rest of the season

Dec. 20, 2008: Bergeron registers 4 goals and 14 assists in his first 31 games in his return to the ice but he suffers another concussion when he collides with future teammate Dennis Seidenberg, then with the Hurricanes. He will be out for a month.

Jan. 1, 2010: Playing in his first Winter Classic, Bergeron feeds Marco Sturm for the game-winner as the Bruins prevail over the Flyers, 2-1, at Fenway Park.

2010-11 season: There are plenty of highlights in his seventh season, beginning Oct. 28 when he scores his 100th career goal in a 2-0 win over the Maple Leafs. On Dec. 23, he registers his 300th career point with a shorthanded goal against the Thrashers. And on Jan. 11, 2011, he has his first career hat trick in a 6-0 win over the Senators.

June 15, 2011: Bergeron scores twice in Game 7 as the Bruins capture their first Stanley Cup in 39 years with a 4-0 win over the Canucks in Vancouver. Bergeron tallies 6 goals and 14 assists in the postseason run.

April 7, 2012: Bergeron closes out the 2011-12 regular season in style, recording 3 points to reach 400 for his career. The Bruins lose to the Capitals in the first round of the playoffs in seven games, but Bergeron would be named winner of the Selke Trophy as best defensive forward for the first time.

May 13, 2013: One month removed from the Boston Marathon bombing, the Bruins trailed Toronto, 4-1, in Game 7 of the first playoff round, but they managed to pull within a goal late in the third period. Bergeron sends the game to overtime when he scores with 50.2 seconds remaining, then adds the winner six minutes into the extra session to set off a raucous celebration.

The Bruins would get back to the Stanley Cup Final but lost to the Blackhawks in six games. Bergeron was injured in the first period of Game 5 and missed the rest of the contest with a broken rib.

He was back in action for Game 6 but was admitted to a hospital immediately afterward with a punctured lung that was caused either by the broken rib or a nerve-blocking injection. It was later revealed that he also had a separated shoulder.

Oct. 25, 2014: In a 4-3 win over the Maple Leafs, Bergeron records a pair of assists to reach 500 career points. Later in the season, he reaches 200 goals on Feb. 22, 2015.

Feb. 20, 2016: Nearly one year after reaching 200 goals, Bergeron has a pair of assists to register his 600th point in a 7-3 win over the Stars. He would go on to set a career high in goals with 32, to go along with 36 assists.

Jan. 6, 2018: Bergeron reaches 700 points in impressive fashion, getting his second hat trick and finishing with four goals on the night in a 7-1 thrashing of the Hurricanes. Less than two weeks later, he has another hat trick in a 5-2 win over the Islanders.

Oct. 8, 2018: In what would be another remarkable season for Bergeron and the Bruins, he records his fourth career hat trick in just the third game of the season, a 6-3 win over the Senators.

Dec. 22, 2018: After missing a month with a rib and sternoclavicular injury, Bergeron returns to score a pair of goals to reach 300 in a 5-2 win over the Predators.

Feb. 5, 2019: Playing in his 1,000th game, Bergeron scores a pair of goals in a 3-1 win over the Islanders. After being honored four days later before the Bruins faced the Kings, Bergeron grabs the spotlight with the overtime goal for a 5-4 win.

March 16, 2019: In a victory over the Blue Jackets, Bergeron reaches 800 points with a power-play goal, then assists on Brad Marchand's winner in overtime.

June 2019: After setting a career high in points for the regular season with 32-47—79, Bergeron follows with a career-high nine postseason goals to go with eight assists in 24 games as the Bruins reach the Stanley Cup Final. They fall short, losing to the Blues in seven games.

Oct. 27, 2019: Bergeron has his fifth career hat trick in a 7-4 win over the Rangers, then records his 500th assist less than week later in a 5-2 win over the Senators Nov. 2.

March 5, 2020: In what would turn out to be one of the final games of the regular season with the pandemic bringing the sports world to a halt less than a week later, Bergeron becomes the sixth Bruin to record six 30-goal seasons.

Jan. 7, 2021: With the Bruins parting ways with longtime captain Zdeno Chara, Bergeron is the obvious choice to wear the C on his jersey. But before they made the move official, the Bruins had some fun, with general manager Don Sweeney saying that the new captain would be Marchand.

Feb. 3, 2021: Bergeron's goal 31 seconds into overtime caps a 4-point night and a 4-3 win over the Flyers. It is his ninth overtime winner.

April 5, 2021: One night after moving past Rick Middleton into fourth on the Bruins all-time scoring list with a power-play goal against the Flyers, Bergeron reaches 900 points and records his sixth hat trick in a 4-2 win over the Flyers.

Nov. 4, 2021: Bergeron accounts for four of his team's five goals in a 5-1 win over the Red Wings, his seventh hat trick and second four-goal game.

Dec. 11, 2021: With a pair of assists in a 4-2 win over the Flames, Bergeron moves ahead of Phil Esposito for fourth on the franchise list.

April 28, 2022: Bergeron reaches 400 goals in style, getting his eighth hat trick in the regular-season finale.

June 5, 2022: Bergeron wins the Selke Trophy for a record fifth time. He first won in 2012, and then again in 2014, 2015, and 2017.

Aug. 8, 2022: Saying that Boston is his home, Bergeron announces that he is returning for a 19th season.

Oct. 18, 2022: It would go down as a 7-5 loss, but Bergeron moves past Rick Middleton for third on the Bruins' all-time goals list at 403 when he nets one in the third period.

Nov. 7, 2022: Bergeron's leadership is put to the test when the Bruins sign Mitchell Miller, a prospect who admitted to bullying and racial abuse of a developmentally disabled peer. The captain makes it clear where he stands when asked what he said to management when consulted about the move:

"As a person but also as a team, we stand for integrity and inclusion and diversity, obviously. That was the first thing that came out of my mouth, was that it goes against what we are as a culture and as a team. And for me as a person."

The Bruins reverse course and part ways with Miller two days later.

Nov. 21, 2022: It certainly doesn't seem like a road game when Bergeron records his 1,000th point against the Lightning at Amalie Arena. After assisting on Marchand's goal in the second period, Bergeron is swarmed by teammates, with the visitors bench emptying out onto the ice to celebrate. Both Bruins and Lightning fans treat him to a standing ovation.

The Bruins would salute Bergeron with a pregame ceremony at TD Garden Dec. 17.

Jan. 7, 2023: With two assists in a 4-2 win over the Sharks, Bergeron moves past Phil Esposito for third in points in Bruins history.

April 30, 2023: Bergeron plays his final game in a Bruins uniform. After a record-breaking regular season, the Bruins are knocked out of the playoffs by the Panthers in the first round.

July 25, 2023: Bergeron retires. ■

Patrice Bergeron cited the need for more quality time with family as one of the main reasons that he decided to hang up his skates.

THE FINAL SHIFT

Body and Mind Told Bergeron It Was Time to Retire

By Kevin Paul Dupont | July 26, 2023

As with most, even la crème de la crème like Patrice Bergeron, body and mind make the decision.

In the end, those two voices told him it was time to go. The day had arrived. Time for Patrice Bergeron-Cleary to navigate life elsewhere than on a 200-foot patch of ice framed by wins, losses, points, short walls, and sky-high hopes.

"I'm a very intuitive guy," said the now-former Bruins center in his career farewell Wednesday at TD Garden. "I feel like I always listen to my instincts and my heart, and it just felt like it was time for me to move on.

"I wish I could play forever and never have to do this, but as you know, eventually you have to move on. The body tells you some things sometimes."

And then, with the clock on Causeway Street reading 12:12 p.m. on July 26, 2023, the most complete center in Bruins history officially capped his final performance on the third floor of the Garden.

Just down the hallway from where Bergeron said goodbye, the cement floor was stripped bare, its huge Spoked B still weeks from being painted across center ice for the start of the 2023-24 season. Other than the intermittent clank-tap of a worker's

Patrice Bergeron's body took plenty of punishment throughout the course of his career, but he always found a way to bounce back and excel along the way.

tool, it was a quiet summer's day, tinged with the somber, albeit inevitable, moment of goodbye.

A new iteration of Bruins hockey awaits, one no doubt different and undeniably more challenging, with Bergeron gone.

"It will be a nice change," mused Bergeron, 38, with 1,464 games on his NHL odometer, "to just be able to be the Uber driver for the family."

Bergeron will be back one day soon, date to be determined, to see his No. 37 retired to the rafters ("That's a no-brainer, right?" team president Cam Neely said).

In three years (mandatory waiting period), he'll pull on the tailored blue jacket and gold ring at the Hockey Hall of Fame in Toronto. Easier to believe that water doesn't freeze at 32 degrees than to think Bergeron is not a first-ballot HHOFer.

Other than that, at least in the immediate, "Bergy" has nothing booked in his weekly, monthly, or yearly planner. After an estimated career earnings of just under $100 million, he has his eye set on being a husband, a father to four young kids, and remaining reasonably fit without the pressure of summer ending and training camp starting.

It would have been his 20th NHL season, but No. 19 was enough. His body and mind told him so.

"It will be nice," he said, "not to have like a schedule or an endgame, if you will. And we'll see, maybe I'll need something like Z [Zdeno Chara] . . . He ran a marathon [immediately following retirement]. Obviously, the competitive nature is always going to be there."

Perhaps a future in coaching? Over the last five to six years, whenever the topic of retirement came up, Bergeron shot down the idea of working behind a bench. That hasn't changed. At least

it hadn't less than 90 days after shuffling off Garden ice following the first-round loss to Florida in the playoffs.

"Yeah, I don't think [coaching] is in the cards for now," he said. "I mean, never say never, and we'll see what can happen eventually. But for now, I have a lot of catching up to do at home."

He sounded definitive only about the Bergerons living at least one more year in the Boston burbs. After that, it could be time to move everyone back to Quebec City, to live among extended family. But again, he noted, no need to decide that now.

"It's also an easy drive or an easy flight," he said. "So we'll make it work."

Bergeron arrived in Boston as an unknown from Quebec, the 45th pick in the 2003 draft, another anonymous 18-year-old to trickle out of the endless pipeline of starry-eyed teenaged dreamers.

His game was ahead of his English, so much so that then-coach Mike Sullivan had not the slightest reluctance in plugging him right into the varsity lineup. His No. 1 asset: He knew where to be on the ice. For the next two decades, he was never out of place, the rare savant in terms of spatial awareness and anticipation.

"It's a gift, really," said Neely, speaking in present tense of a career now in the past. "When you watch him play, he's always in the right place on the defensive side or the offensive side. Rarely do you find him where he should not be on the ice. That's a gift, whether it's a God gift or you learn it . . . but over the years he figured out how to play the game."

For Neely, general manager Don Sweeney, and the rest of the front office cognoscenti, the Herculean task now — *la tache impossible* — will be to figure out life going forward without Bergeron. It

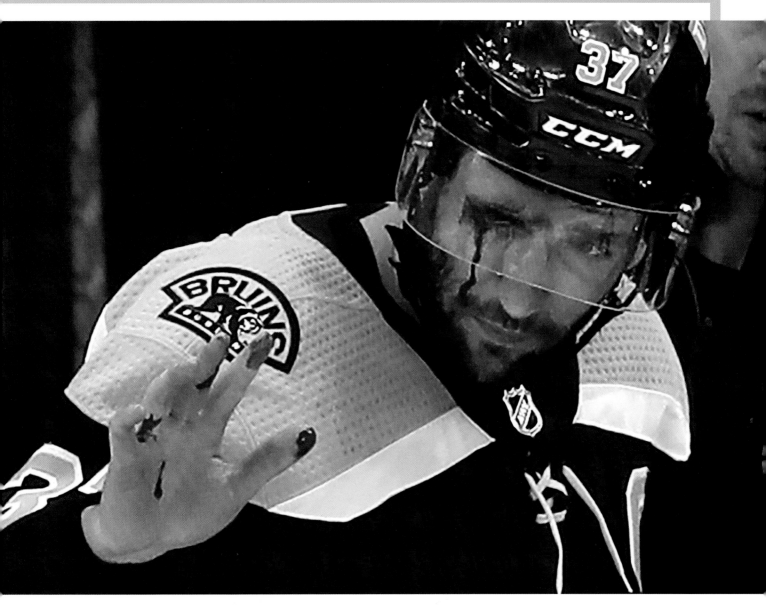

will be a topic for weeks, months, and seasons to come — for fans, media, and sports radio yakmasters.

There will be no like-for-like replacement, because not even an AI hockey app could concoct a second Bergeron with the same skill set, IQ, awareness, and unremitting competitiveness. In that sense, the closest the game has ever seen was Brett Hull following in his father Bobby's footsteps, the Golden Brett a virtual duplicate of the Golden Jet.

"I think the one thing I'll definitely say is I left everything out there," said Bergeron, when asked what his legacy might be. "I have no regrets on anything, and I gave my all."

He gave until the end, until time ran out, 19 seasons in the books, 12:12 on the clock. Bruins fans soon will start their hopes anew, richer for having witnessed a career well played to the final shift. ■